IMAGES
of America

LEAVENWORTH

The Upper Valley Museum at Leavenworth is located at the house pictured above, now known as the Barn Beach Reserve. It was built in 1903 and was once the summer home of Lafayette Lamb, one of the founders of the Lamb-Davis Lumber Company. The town banker, R. B. Field, purchased the house in 1921 and he and his family lived there until 1967. The building got its present name from the horse barns of the Bent River Arabian Horse Ranch, where the Field family raised its horses. The property is adjacent to the Waterfront Park and Blackbird Island, creating more than 40 acres of beautiful greenbelt for the public to enjoy. (Courtesy of the Upper Valley Museum at Leavenworth.)

ON THE COVER: This photograph of the Daly home was taken in 1908 by well-known photographer J. D. Wheeler. The names listed on the back of the image are Mrs. Geo Daly, Myrna Daly (Angel), Mrs. Brown (Lyda's mother), Lyda Brown (Burgett), Mrs. Grandma Allison (sitting, Howard's grandmother), Sam Daly, Nate Coleman, D. A. Burgett, Geo Daly, and Dick Daly. This home is still standing and is the present site of the Gingerbread Factory. (Courtesy of the Upper Valley Museum at Leavenworth.)

IMAGES
of America

LEAVENWORTH

Rose Kinney-Holck and the
Upper Valley Museum at Leavenworth

ARCADIA
PUBLISHING

Published by Arcadia Publishing
Charleston, South Carolina

Printed in the United States of America

Library of Congress Control Number: 2010933370

For all general information, please contact Arcadia Publishing:
Telephone 843-853-2070
Fax 843-853-0044
E-mail sales@arcadiapublishing.com
For customer service and orders:
Toll-Free 1-888-313-2665

Visit us on the Internet at www.arcadiapublishing.com

To my husband, Jim, and my daughters, Ashley and Allison.

CONTENTS

Acknowledgments 6

Introduction 7

1. Early Days 11

2. Boom Town 23

3. Forest Service 57

4. Camp Icicle 63

5. Fish Hatchery 71

6. Ski Hill 79

7. L.I.F.E in Leavenworth 91

8. All-America City 111

9. Community Pride 119

About the Organization 126

Bibliography 127

ACKNOWLEDGMENTS

I would like to thank the immensely helpful and wonderful staff at the Upper Valley Museum at Leavenworth, without whose help and guidance this book would have never been possible. A special thanks goes to Ann Ostella and Bill Haines. Your enthusiasm and support was critical to getting this project off the ground. Thanks also goes out to Steve Croci, Corky Broaddus and Lynann DeJarnett of the Leavenworth National Fish Hatchery, Mark Behler of the Wenatchee Valley Museum and Cultural Center, Bill Calvert for the Jack Holt photograph, Chris Rader for the "Dude" photograph, Susan Peterson from the Okanogan-Wenatchee National Forest, Paula Helsel from the Sleeping Lady Mountain Resort, John S. Kruszka, Becky Morgan, and Ron Wodaski for their railway expertise, and Marsha Skrypuch for being a great friend and mentor.

Carol Forhan graciously allowed me to dig through the archives of the *Leavenworth Echo*, which was a tremendous help. Thank you, Carol!

I would also like to thank my editor at Arcadia Publishing, Donna Libert, and publisher Devon Weston who made the entire process from proposal to completed book as smooth as could be. Thank you both for always being there for me.

Last but not least, I would like to thank my wonderful husband, Jim, and my beautiful children, Ashley and Allison, for their incredible patience.

INTRODUCTION

The Christmas Lighting festival in Leavenworth is like no other in the country. Amidst the picturesque backdrop of the snowcapped Cascade Mountains, which rise between 5,000 and 8,000 feet, the town comes alight to the sounds of "Silent Night" for three consecutive weekends each December. This could be one of the reasons why *Time* magazine listed Leavenworth as one of the top 10 places to find the most holiday cheer and why *Good Morning America* came twice to take part in lighting the town. There are indeed many other accolades bestowed upon this quaint Bavarian village. Tourism is the backbone of today's Leavenworth. How did this all begin?

Icicle Valley was a bountiful home for the Wenatchi, Chinook, and Yakima tribes who fished at the confluence of the Icicle and Wenatchee Rivers. During the spring, they traveled to "Cottonwood Place," now known as Ephrata, to dig camas and other edible wild roots, but once the hot summer months began, they journeyed through the valley to Lake Wenatchee, gathering berries and seeds along the way. Then it was back to the Icicle River where salmon were plentiful, as were game such as deer and elk, and many edible roots were ready for gathering. Tribes from throughout the inland Northwest gathered here this time each year to hunt, gather, and socialize. Life was quite peaceful for the Native Americans who made the valley their home, though change was on the way.

Trappers and explorers from the Hudson's Bay Trading Company wandered through from time to time and in 1869 the nearby Blewett mining town was established. This little mining town was deemed one of the most violent mining towns in Chelan County due to excessive fighting and shootings mostly over hidden pockets of ore, which the greediest of the prospectors would come back in the dark of night to take. The prospectors, lured by the possibility of striking it rich, were among the first white men to settle in Icicle Valley. Then came the arrival of pioneer families, and by 1893, the population of this peaceful area rose to approximately 700. Unfortunately they brought diseases such as measles and small pox, which decimated the population of the Wenatchi.

By that time, the town of Icicle Flats, located in the heart of Icicle Valley, was now known as Leavenworth, named after Charles Leavenworth of the Okanogan Investment Company. He wisely platted the town adjacent to the planned location of the tracks of the Great Northern Railway. The route was completed in 1893 and Leavenworth became a divisional hub with company offices, a depot, and a roundhouse for turning engines. The tracks continued west through the Tumwater Canyon where the Wenatchee River flows. A dam was constructed there to provide power for the locomotives to travel through the tunnels, which ran through the Cascade Mountains. Rail workers came from near and far, and many called Leavenworth home.

Around this same time period, a prominent lumberman from Iowa, Chauncey Lamb, sent his son Lafayette out west to purchase several stands of lumber near Leavenworth, and in 1903 the Lamb-Davis Lumber Company was incorporated. Lafayette Lamb served as president, and copartner Petrel Davis served as treasurer and general manager. The company was located along the banks of the Wenatchee River and brought more men seeking work. A dam was built on the Wenatchee River at the site of the sawmill, which created a millpond. Trees were logged upriver

near Lake Wenatchee and floated down to the millpond and sent up to the mill for processing. By 1906, the Lamb-Davis company employed more than 250 men at the mill in town and also as loggers along the river.

On top of it all, thousands of apple and pear trees were planted along Icicle River and throughout the valley, creating a hugely successful fruit industry. The population of Leavenworth boomed with the continued influx of people, which was around 1,000 in 1906—the year Leavenworth became incorporated. The population boom brought on by the railroad and sawmill led to problems that other old west towns experienced: lawlessness.

This prompted the need for a town marshal, and Noble L. "Dude" Brown was chosen. He was a quiet fellow known for his flair for the fast draw. With the Great Northern Railway and Lamb-Davis Lumber Company mill in town, many workers took to frequenting whorehouses and saloons, which outnumbered churches at the time. On the whole, times were good for the residents of Leavenworth and the future looked bright. Shops, restaurants, and hotels opened their doors and business was booming. At this point, Leavenworth required a town cemetery, so one was created just off North Road. Early homesteaders such as John and Nick Emig, among other men, women, and children, were buried there.

In 1908, the Wenatchee National Forest established a headquarters in Leavenworth. At this time there were nearly 150,000 sheep that grazed the forest and rangers would travel on horseback to oversee the grazing. Rangers' other duties included mapping, building trails, and fire lookouts—the latter very critical since summers in the Wenatchee National Forest were, and still are, dry and prone to forest fires. The headquarters' first supervisor was A. H. "Hal" Sylvester, who is credited with naming many of the surrounding peaks, lakes, and creeks. The headquarters moved in 1921, but the Leavenworth ranger district continued to provide regular, seasonal employment.

Unfortunately the frequently heavy winter snows continued to plague the Great Northern Railway's section through the Cascade Mountains. Slide after slide occurred and on March 1, 1910, one of the worst catastrophes to hit Washington State happened: the Wellington Disaster. In February, the Cascades were assaulted by one of the worst blizzards in history, lasting a total of nine days. As much as a foot of snow per hour fell during this time and two trains, both bound for Seattle, were trapped in the depot. Snowplows were present but could not dent the massive accumulations of snow between Scenic and Leavenworth. On February 28, the snow turned to rain and a warm wind blew through the canyon. That, combined with the violent thunderstorms, brought the snow thundering down the mountain. The train depot, with the two trapped trains, was directly in the path. Ninety-six people lost their lives that day. It took Great Northern Railway workers three weeks to repair the tracks. In October 1910, Wellington was renamed Tye due to the tragic associations with the old name. In that same month, the Great Northern Railway began constructing concrete snowsheds to shelter the nearby tracks.

After years of debilitating snowslides and avalanches, the Great Northern Railway made the decision to reroute the tracks from their current location in the Tumwater Canyon through the less-hazardous Chumstick Valley, thus moving the tracks more than a mile away from Leavenworth, and the divisional hub was moved farther east to Wenatchee. The Lamb-Davis sawmill closed in 1916 and was reopened as the Great Northern Lumber Company, not related to the Great Northern Railway. Unfortunately, in 1926, the mill closed forever. The economy of Leavenworth plummeted. The Great Depression loomed. With businesses and people leaving, the town seemed to be dying a little each day.

Dedicated residents remained and it was small-town business as usual. Orchardists continued growing fruit, the Trinity mine, located near the Chiwawa River, was still in operation, logging was still important to the area, and skiing was a favorite pastime for many residents. The Leavenworth Ski Hill was developed during the 1920s, and from the 1930s to the mid-1970s it hosted annual ski tournaments. Visitors came from all around the state via car and train to see the ski jumpers, some of whom traveled from as far away as Norway to compete. Visitors arriving by car traveled the Stevens Pass Highway, which was officially opened in 1925. The highway, which ran right

over the old Great Northern Railway tracks through the Tumwater Canyon into Leavenworth, was a boon to the Leavenworth economy. Other jobs were still available at local businesses and the Cascade Sanitarium, which opened in 1923.

In 1932, the Civilian Conservation Corps was born. Created by Pres. Franklin D. Roosevelt, the corps provided employment to approximately 275,000 young men across the West. In 1933, Camp Icicle was established and housed 226 young men during its first summer of operation. Their responsibilities included mapping, surveying, thinning timber stands, firefighting, and constructing buildings and roads. Many of the men also attended classes while at Camp Icicle. They had the wonderful opportunity to learn forestry, grammar and spelling, and first aid, among other subjects.

In 1939 and 1940, the Leavenworth National Fish Hatchery was built on Icicle River. Salmon migration was brought to an abrupt halt with the building of the Grand Coulee Dam on the Columbia River. All rivers and tributaries upstream were affected. To offset the loss of many miles of salmon spawning habitat, the federal government built hatcheries to help restore the salmon population. To help keep the waters cool during the hot summer months, the Upper Snow Lake was deemed a perfect reservoir. A 7-foot diameter tunnel with a control valve was built between Upper Snow Lake and Nada Lake where the water could then be sent downstream to the hatchery when needed. It was a hugely successful undertaking. The Leavenworth National Fish Hatchery currently raises and releases 1.2 million juvenile spring Chinook salmon into Icicle River.

Despite these positive events, Leavenworth was still a declining town. Leavenworth's economic condition was dire. Businesses were in disrepair or closing; restaurants sat empty. Townspeople shopped in other nearby towns for their goods and services and Leavenworth was dubbed a welfare town. Leavenworth High School had even been condemned. There was extreme discord about where the new school should be located. The community was torn apart and there was a pervading feeling of desperation. But along came Ted Price and Bob Rodgers, two men whose vision of Leavenworth's future changed the town forever.

In 1960, Price and Rodgers purchased the nearby Cole's Corner Café, gave it a Swiss-Bavarian remodel, and named it the Squirrel Tree. People living in the area as well as travelers over Stevens Pass loved the alpine-themed restaurant. It was a hit. However, businesses in downtown Leavenworth were still struggling. Then in 1962, the chamber of commerce contacted the University of Washington's Bureau of Community Development. The bureau provided Leavenworth with a way for the townspeople to find their own solutions to their current dilemma. It was a self-study in which the townspeople would not be told what to do but how to work together to find solutions and how to find the resources to help with their endeavors. Leavenworth Improvement for Everyone, known as Project L.I.F.E., was born. Around 200 of the town's 1,500 people pitched in and began working on various committees that sprang up as a result of Project L.I.F.E. Leavenworth's spirit of cooperation and togetherness was rekindled, and from this point on the town was again on the verge of an upswing, whether they knew it at the time or not.

During a committee meeting in June 1964, it was decided, after lengthy and heated discussions, that it was feasible to begin work on updating Leavenworth to reflect an alpine Bavarian theme, which was inspired by the Danish village of Solvang located in California. Shortly thereafter, and not without some resistance and discord, the rest of the town began the Bavarian transformation at their own expense. Ted and Bob, along with folks like Pauline and Owen Watson, LaVerne Peterson, and Verne and Ann Herrett, were the first to begin planning their remodeling. Once word got out to other communities about what was happening in Leavenworth, Earl Petersen arrived unsolicited from Solvang to help out. About a month later, Heinz Ulbricht, who had read about Leavenworth going Alpine in the *Seattle Times*, arrived in town ready to get to work. Most of the Bavarian designs in Leavenworth can be attributed to him. He had an eye for detail and authenticity, which the store owners appreciated.

After the first six buildings were remodeled, the rest followed suit. Between all the chamber and Project L.I.F.E. meetings, it was also decided to begin attracting tourists to Leavenworth by

hosting festivals. The Autumn Leaf Festival began in 1964 and is still going strong. The city also showed its spirit by consistently entering themed floats in Wenatchee's Apple Blossom Festival and has won many awards. Other festivals followed suit: the Christmas Lighting Festival, Maifest, Oktoberfest, and many more became highly successful. In fact, one would be hard pressed today to come to Leavenworth on a weekend when there wasn't a festival occurring.

The Jr. Vesta Women's club was also a great booster for the community. These 11 dedicated women won for their community a $10,000 grant from the Sears Roebuck Foundation and the General Federation of Women's Clubs in recognition of their community service. This grant money was used to contribute to such necessities as a new ambulance, and they also went on in later years to contribute to beautification of the city park.

Then in 1967, the chamber applied for *Look* magazine's All-America City Award and was chosen as one of the top finalists. A delegation needed to travel to Milwaukee, so the chamber was faced with the dilemma of how to cover the expenses. Once again, the town pulled together. A fellow named Archie Marlin sold hot peanut brittle in the park and members of the Tamarack Women's Club held a rummage sale. Other organizations and individuals donated money and some of the expenses were covered by the delegates themselves. In 1968, the chamber of commerce received a letter announcing that Leavenworth had indeed won the award.

The story of Leavenworth is told here with photographs—frozen moments in time in which the reader can piece together Leavenworth's rich history from the times of the earliest inhabitants to the Bavarian-themed tourist destination that it is today. The most common thread in this little city's history is perseverance and volunteerism, which have fueled the contagious spirit one will have to experience for his- or herself.

One

EARLY DAYS

Among the earliest inhabitants of Leavenworth were the Wenatchi people, known as the *P'squosa* in their own language. The name Wenatchi, which is derived from *Shahaptian*, means "water coming out." This possibly referred to the Tumwater Canyon. Photographer John Wheeler, also known as J. D. Wheeler, captured many moments in time such as this during the early days of Leavenworth. Mountain Home can be seen in the background, and the woman in the center is holding a small child in front of her. (Courtesy of the Upper Valley Museum at Leavenworth.)

Some Wenatchi, such as Misheetwie pictured left, chose to stay in the Leavenworth area after white settlers began to arrive. Many longtime residents of Leavenworth still fondly remember stories about "Indian Mollie" and how she rode to town on her pony to visit, as shown below. She was known to exchange food and gifts with some of the residents. She would sometimes bring *pemmican*, a combination of camas root, dried berries, raisins, and sugar mixed with deer or bear fat. Misheetwie is posing in this 1897 photograph, shown at left, on grounds that appear to be the present Barn Beach Reserve and home of the Upper Valley Museum at Leavenworth. She lived alone in Olalla Canyon, some 17 miles east of Leavenworth. (Left, courtesy of the Upper Valley Museum at Leavenworth; below, courtesy of the Wenatchee Valley Museum and Cultural Center No. 003-60-3.)

Teesahkt, known as "Clotilda Judge," was the sister of Misheetwie and lived closer to Leavenworth. Teesahkt died in Leavenworth in 1935; she and Misheetwie are buried in the Native American cemetery near Cashmere. Many of her fellow Wenatchi died several years earlier. Once the white man began settling in the Leavenworth area, they spread smallpox, measles, and other "white diseases." By the late 1800s, epidemics and diseases such as these reduced the tribe from about 1,400 in 1780 to just a few hundred. Today the Wenatchi are recognized as one of the 12 bands that make up the Colville Confederated Tribes, having been forced from their own homeland despite it being promised to the tribe in the 1855 Walla Walla Treaty. Though most descendants of the Wenatchi people live successful lives elsewhere in the state, their strong feelings for the region remain. (Courtesy of the Upper Valley Museum at Leavenworth.)

The Icicle River, pictured above, was a favored fishing area to the Wenatchi people, who called it *Nasikelt* meaning "narrow bottom canyon." They lived, worked, and played at the confluence of the Icicle and Wenatchee Rivers. During the spring, the Wenatchi journeyed to Cottonwood Place, now known as Ephrata. There, they used digging sticks to harvest edible roots such as camas. Many other tribes gathered with them and when summer came, they traveled back to Icicle Valley, gathering berries along the way. They hunted deer and celebrated the return of the salmon. As many as 2,000 people came for this celebration and stayed in teepees, as seen in the photograph below. These Native Americans pose in front of a drying rack that has salmon hanging from it. (Above, courtesy of Bill Haines; below, courtesy of the Upper Valley Museum at Leavenworth.)

Daniel Chipman Linsley was an engineer who was sent out to find the most feasible route through the Cascade Mountains for the Northern Pacific Railway and was one of the first white men to encounter the Wenatchs. Of the Tumwater Canyon and their fishing method, he wrote in his diary, "The stream flows over and around huge boulders of granite and seems one mass of snowy foam. Here the salmon collect in great quantities and hither every year come great swarms of Indians to lay in their year's stock of food . . . The fish are taken by means of a barbed hook attached to the end of a slender pole from 15 to 30 feet long . . . The women then take them, cut them up, and hang them on poles to be dried and smoked." A representation of this fishing method is shown above. (Courtesy of the Upper Valley Museum at Leavenworth.)

A historic powwow was held near Cashmere in August 1931, its purpose being to call attention to unfilled treaty obligations as well as to boost the economy of the Cashmere area. J. Harold Anderson, a Cashmere attorney who represented the Wenatchi tribe, was one of the organizers of the event. It was through chief John Harmelt, the last hereditary Wenatchi chief seen in this August 1931 photograph, that Anderson became aware of the unfair treatment of these Native Americans. The treaty in question was the Walla Walla Treaty of 1855 that deeded Wenatchi land to the Yakama Nation. The treaty also stipulated continuing fishing rights at the Wenatshapam Fishery Reservation, located in present Leavenworth at the confluence of the Icicle River and the Wenatchee River. Unfortunately this reservation was never established. There were many court battles through the years between the Yakama Nation and the Wenatchi tribe, and in June 2010 it was decided that both the Yakamas and the Wenatchis retain nonexclusive fishing rights at Icicle River. (Courtesy of Manuscripts, Archives and Special Collections, Washington State University Libraries, pc20m05a.)

These two photographs were taken at the historic Grand Powwow and Historical Pageant held near Cashmere August 20–22, 1931. The original intent of the powwow was to help chief Harmelt assemble the remaining Wenatchis for a tribal business meeting and to present their grievances to Native American agents. As it turned out, the powwow was also a grand celebration of their culture and included a parade, traditional dancing, Native American foot races, and pageants every night of the event. Non–Native Americans attended and admittance was charged to boost the area's Depression-era economy. Pictured above, from left to right, are Mary Felix, Ellen Harmelt, and chief John Harmelt. Harmelt is also seen posing in the photograph at right. (Both courtesy of Manuscripts, Archives and Special Collections, Washington State University Libraries, pc20m18 and pc20m05.)

Beginning in the 1860s, prospectors returning from the Okanogan and Fraser Rivers regions certainly added to Leavenworth's growing population and economy. Sifting through gravel deposits for gold in nearby creeks—a method known as placer mining—was popular. When loose gold became scarce, prospectors began looking for hard rock gold. This 1895 photograph shows the nearby mining town of Blewett, looking south up Peshastin Creek. The large building on the right housed the twenty-stamp mill, a device used to pulverize ore by dropping heavy stamps on it. The stacked cordwood in front of the mill was used to keep fires lit for the operation of the mill. This combined with the water provided by the flume, which can be seen just above the main roof of the mill, were the ingredients for steam power. Directly across from the pile of cordwood is the town's three-story hotel. Just behind the hotel, the roof of the schoolhouse can be seen. (Courtesy of Bill Haines.)

With more and more prospectors arriving in the area, accommodations for families with children were needed. The original Blewett schoolhouse, which was built from logs from the surrounding forest, is shown above in this 1893 photograph. The schoolmaster is on the far left posing with the teacher and pupils in front of this sturdy building. Shown in the photograph at right is the schoolmarm posing with her students in front of the clapboard schoolhouse, which replaced the older log building. Though there were many services in Blewett, the residents often needed to travel to Leavenworth for goods and services, most notably medical care. (Both courtesy of Bill Haines.)

In this c. 1902 photograph, miners pose in front of what could possibly be the Blackjack Mine. This mine, located on the Peshastin Creek upstream from Blewett, was opened in 1890. Legend tells that some of the men who worked this mine would find ore in pockets which they then concealed as well as they could. Then they would come back later in the night to remove the

ore and sell it themselves. It is no wonder then that Blewett was known to be the most violent mining town in Chelan County due to shootings and fights. Notice that this group of men are all holding fresh candles indicating they were preparing to enter the mine. Candles were the only source of light to the miners in those days. (Courtesy of Bill Haines.)

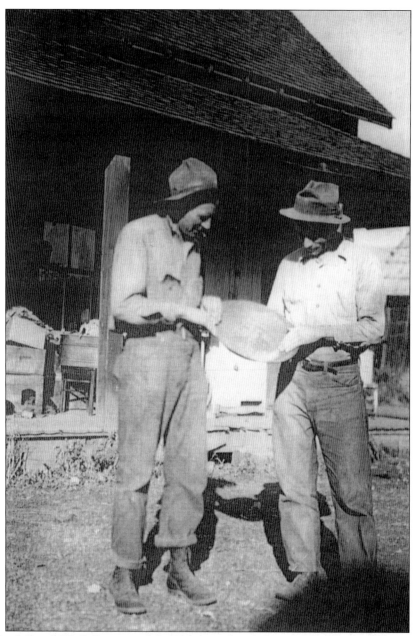

Ralph Lindall and W. O. Burgess, of the Plain area located near Leavenworth, are seen in this photograph reminiscing about the good ole days of mining. Not only were there claims in the Blewett area near Peshastin Creek but there were also mines located in the Chiwawa area near Plain. One such mine was the Trinity mine, which was a subsidiary of the Royal Development Company. This mine produced mainly copper ore, but silver, gold, and tungsten were also found as byproducts. The Royal Development Company employed many local men and erected a camp that included a lumber mill, water power, and housing for its employees. In 1937, operations began to slow down and the Royal Development Company eventually dissolved in 1948. The town site remains today as a ghost town but is currently owned by a private party. (Courtesy of the Upper Valley Museum at Leavenworth.)

Two

BOOM TOWN

In this "First Picture Taken of Leavenworth, 1908," the Great Northern Railway can be seen. The town was previously known as Icicle and was located at the confluence of the Wenatchee and Icicle Rivers. In 1892, Capt. Charles Leavenworth, a major investor of the Okanogan Investment Company, platted the town to parallel the railroad tracks. By 1905, seven sets of tracks ran through Leavenworth on the present location of U.S. Highway 2. (Courtesy of Bill Haines.)

During the late 1800s, surveyors for the Minnesota-based Great Northern Railway were still on the hunt for the most feasible route through the north Cascade Mountains. The *c.* 1913 photograph at left shows the Great Northern Railway's president, James Jerome Hill, who was the mastermind behind it all. He was interested in opening up trade to the west, and once the best route through the formidable Cascades was discovered by John F. Stevens, Hill worked quickly and at his own expense to extend the rails to Wenatchee and westward over Stevens Pass. In the photograph below, the Great Northern Railway depot and tracks through town can be seen. The depot sits at the current location of Gustav's restaurant. (Left, courtesy of the Library of Congress, Prints and Photographs Division, photograph by Harris and Ewing, LC-H261-3713; below, courtesy of the Upper Valley Museum at Leavenworth.)

The presence of the Great Northern Railway in Leavenworth opened up numerous entrepreneurial opportunities for residents. Frank Losekamp, one of the town's first storekeepers, built the brick building in this c. 1908 photograph in 1906. It housed the Tumwater Bank, L. D. Company Store, a grocery store, and Chikamin Hotel. (Courtesy of Bill Haines.)

The pioneering Brenders, responsible for various businesses throughout the last century, owned a horseshoeing and blacksmithing shop. Posing for this 1905 photograph, from left to right, are Noble "Dude" Brown, Rein Templin, and Fred Brender. This business thrived until the appearance of the automobile. The building, located on Commercial Street, still stands. (Courtesy of the Upper Valley Museum at Leavenworth.)

The Great Northern Railway was the major employer in Leavenworth from the late 1800s to the early 1900s. The Gutherless family was one of the railroad families. They lived in a Great Northern Railway construction camp a few miles up Tumwater Canyon. In the photograph at left, Frances Gutherless poses with her clever invention. She created this modified baby carriage to push her children to town. The carriage had a wheel underneath that allowed her to follow along the railroad tracks when the train was not running. The structure behind her is one of five snowsheds that were built along the tracks in the Tumwater Canyon to protect the trains and tracks from the frequent winter snow slides. Below, the Gutherless family is seen in this photograph from around 1915 with their altered invention. (Both courtesy of Bill Haines.)

Rail construction camps popped up all along the Great Northern Railway to house workers. A footbridge was necessary to cross the Wenatchee River from the construction camp in this area. Frances Gutherless is seen in the photograph at right, mid-span above the raging waters in the Tumwater Canyon, which was 3,000 feet deep and 10 miles long. The bridge was the only way workers could cross the river to reach the railroad tracks that they followed approximately 2 miles into Leavenworth. This footbridge is no longer part of the Tumwater Canyon landscape. The photograph below shows the bridge from a different perspective. A snowshed constructed of timbers is seen in the background. The snowsheds in Tumwater Canyon are no longer present. (Both courtesy of Bill Haines.)

The 1915 photograph above is of the Great Northern Dam in the Tumwater Canyon, a few miles east of Leavenworth. The photograph below is of the same dam as seen from upriver. The original rail line was completed in 1893 with a series of switchbacks on the east and west sides of the Cascade Mountains, which were quite hazardous during heavy winter snows. A 2.6-mile tunnel was finally constructed. Excavation crews from the east side met the crews from the west side inside the tunnel on September 23, 1900, and the tunnel opened in December. It became clear that the coal-powered engines would not be safe in the tunnel due to the thick, noxious smoke that was produced. The tunnel had to be electrified, so the dam and related hydroelectric facilities were constructed between 1907 and 1909. (Both courtesy of Bill Haines.)

Wooden penstock pipes were built to carry water from the dam 11,654 feet to the power plant. The photograph above illustrates the sheer size of the pipe. This pipe was constructed of wooden staves bound with heavy steel wire to hold the staves in place and to resist water pressure. The pipeline ran along the river on the bank opposite the tracks due to lack of space trackside. A riveted steel bridge was constructed to carry the penstock across the river to the power plant as shown in the photograph below. The water tank on the right-hand side was constructed to protect the pipeline and the generators from surges in water pressure. The house to the immediate right of the tower was used as living quarters for plant operators. (Above, courtesy of Bill Haines; below, courtesy of the Upper Valley Museum at Leavenworth.)

The headquarters of the Cascade Division of the Great Northern Railway was located in Leavenworth from 1893 to 1925, making the town quite the industrial hub. A roundhouse, depot, coal bunkers, and a switching yard were built beside the tracks. The dark cluster of buildings in the center of the above photograph are the coal bunkers. They are also visible in the photograph below, toward the right-hand side. The building with four upper-floor windows visible on the left-hand side in the photograph below was constructed in the late 1890s. The first floor of this building housed a saloon with a dance hall upstairs. (Both courtesy of the Upper Valley Museum at Leavenworth.)

Shown above is a closer view of a coal bunker in Leavenworth in the early 1900s. This was a major refueling stop for eastbound and westbound trains during Leavenworth's heyday as the Cascade Division hub. Coal was brought up the conveyor belt into the bunker or load-out and a chute was opened when the cars pulled underneath. (Courtesy of the Upper Valley Museum at Leavenworth.)

Locomotives such as these were a common sight in Leavenworth from 1893 to 1925. During its heyday as a rail town, the switchyard handled 1,000 cars a day. Between the Great Northern Railway and the sawmill that would come later, local employment increased and the town swelled with workers and their families. (Courtesy of Bill Haines.)

Not only was Leavenworth an up-and-coming rail town, it was also a mill town. Icicle Valley and the surrounding terrain was rich with Douglas fir and ponderosa pine trees. Small mills were established to provide lumber for early settlers and eventually larger mills were established to supply the Great Northern Railway with lumber as it built its lines through the valley. The Lamb-Davis sawmill was established in 1903 along the banks of the Wenatchee River where Enchantment and Waterfront parks are now. By 1906, the population of Leavenworth had boomed to 1,000 people who were supported mostly by the railroad and mill. Men and boys are posed for the early 1900s photograph above. The photograph below shows a different view of the Lamb-Davis offices. (Above, courtesy of Bill Haines; below, courtesy of the Upper Valley Museum at Leavenworth.)

These early photographs show Leavenworth in its prime. The Great Northern Railway is seen in front of the Lamb-Davis sawmill and lumberyards with the millpond and the Wenatchee River flowing along in the background. When the sawmill was established, a bank, company hotel, and store were built to accommodate the employees. The area known as "Mountain Home" can be seen in the background. The photograph above was taken in February 1907. The photograph below was taken a few years later. Note the difference in lumber production; the stacks of lumber are drastically different in the two photographs. (Both courtesy of the Upper Valley Museum at Leavenworth.)

The Lamb-Davis Lumber Company built a log dam across the Wenatchee River to create a millpond. Loggers in the Lake Wenatchee area would float logs from the lake down the river, through Tumwater Canyon, and into the pond during the springtime. These hardy men who drove the logs downriver were known as "river rats." Along the wood structure atop the dam, as seen in both photographs, men would use long poles to clear debris from the dam. The dam no longer exists today, but pilings can still be seen. Blackbird Island was created by the sediment that accumulated behind the dam. (Both courtesy of the Upper Valley Museum at Leavenworth.)

This bird's-eye view from Tumwater Mountain shows Leavenworth during its boom times. The Great Northern Railway depot is to the right and the tracks extend toward the center of this photograph. In the distance, an overpass can be seen. This was built in 1906 in response to citizens' concerns about peril to the schoolchildren who had to cross the tracks on a daily basis. Several accidents had occurred on the tracks in town, so the Great Northern Railway agreed to pay the construction costs for an overpass and the town agreed to pay for any maintenance needed. Irrigation districts were also formed in the early 1900s to bring water from the Icicle watershed to orchard lands on both sides of the Wenatchee River between Leavenworth and Wenatchee. Pear and apple orchards are seen on the left-hand side of this photograph, taken around 1919. (Courtesy of Bill Haines.)

While the citizens of Leavenworth enjoyed their boom times, they did not necessarily enjoy the lawlessness that accompanied them. In fact, this Wild West railroad and sawmill town had more saloons than churches at the time. Noble Leon "Dude" Brown, posing in sheepskin chaps in the c. 1919 photograph above, was the town marshal who was known for his shooting and riding prowess. When he was not busy keeping the peace, Brown ran a packing and saddle horse business at Icicle River Ranch, about 4 miles upriver. (Courtesy of Chris Rader.)

In 1893, the Great Northern Railway sent Dr. George W. Hoxsey to care for the rail workers from Everett to as far down the line as Wenatchee. His practice in Leavenworth was the first professional medical care for settlers in town. Lake Wenatchee and even Old Blewett, where early miners and prospectors lived, also benefitted from his expertise. He was the quintessential "country doctor" who was known for his tireless and cheerful service, whether it was delivering babies, setting broken bones, or stitching wounds. He made many emergency response trips and house calls on horseback, in a buggy, and on snowshoes during the winter months. When the town was incorporated in 1906, Hoxsey was elected one of the city's councilmen and in 1907 he was elected Leavenworth's second mayor. He later resigned because the job interfered with his medical practice. (Courtesy of Bill Haines.)

Hot Weather Bargains
——at the——
Koerner Stores

NECESSARY - SERVICEABLE - AND CHEAP

Fruit Jars, per doz.............$1 up	Extra Heavy Garden Hose.....10c ft
Jar Rubbers, per doz.............10c	Hose Menders.....................10c
Jar Fillers, each5c	Hose Nozzles....................35c up
Jar Tighteners, each10c	Lawn Sprinklers...............35c up
Preserving Kettles25c up	Garden Hoes.....................30c up
Parafine Wax.....................15c	Garden Rakes...................35c up
Stone Crocks and Jars10c up	Garden Cultivators...........85c up
Strainers10c up	Sprinkling Pots25c up
Big Spoons.......................5c up	Water or Lemonade Sets........45c
Pot Lids5c up	Water Glasses7 for 25c
Asbestos Mats....................5c	Lunch and Picnic Baskets.....10c up
Berry Hullers....................5c	Croquet Sets................... $2.75
Paring Knives....................5c up	Paper Napkins, Paper Plates, etc.

100 new items just added to Notion Department
50 new items just added to Hardware Department

Daily additions to our Line of Hosiery, Underwear, Men's and Ladies' Furnishings, Jewelry, Silverware, etc., make these lines the most complete and lowest in price in this vicinity.

THE $400 PIANO goes to some one in July. Buy everything you can here and save yourself money, and help your friends win the piano. Votes on every purchase.

A SPECIAL SALE OF BROOMS IS NOW ON
Try McDonald's Chocolates--sold only at

The Koerner Stores
"Drugs That Cure"

Ice Cream - Soda - Peanuts - Candies

In the early 1900s, Koerner's Pharmacy was one of the only pharmacies in town. Not only was John Koerner a druggist, he also sold clothing, housewares, and even pianos. The advertisement at left appeared in the *Leavenworth Echo* on June 14, 1912. His store occupied a corner building off Front Street and he rented space in the back to a physician and surgeon. (Above, courtesy of the Upper Valley Museum at Leavenworth; left, courtesy of the *Leavenworth Echo*.)

Although medical care was present very early on in Leavenworth, it was conducted in homes, hotel rooms, and a few private hospitals. Around 1920, R. B. Field, who established the Leavenworth State Bank, was among a group of prominent citizens who organized a committee to build a major hospital facility to benefit the whole town. Of particular interest were patients with lung diseases due to Leavenworth's proximity to the construction of rail tunnels through the Cascade Mountains. The Cascade Sanitarium, pictured above, was built in 1923 and funded by stock purchased by citizens. The sanitarium served the city well until 1979 when a new one, pictured below, was built at the present site on Ninth and Commercial Streets. (Both courtesy of the Upper Valley Museum at Leavenworth.)

Though early Leavenworth could be described as a Wild West town, residents have always been concerned about the education of the town's children. The first schoolteacher was a homesteader named Mary Ralston. An old building was found for her to teach in and families provided the books and supplies for the children. Parents offered room and board as well as a salary for the teachers. As enrollment rose, the need for a new school became clear. The school pictured above was built in 1909 and was the town's first brick building. The high school pictured below joined the grade school in 1912. Both buildings, located on Evans Street, were eventually demolished to make way for newer facilities. (Both courtesy of the Upper Valley Museum at Leavenworth.)

The photograph above is of the Community United Methodist Church. It was established in 1907 and was one of the first churches in Leavenworth. Rev. Melvin Rumohr was the pastor until around 1909. He was a well-known member of the community concerned with the integrity of the town and the wellbeing of the children. According to the November 29, 1907, issue of the *Leavenworth Echo*, he and many other community members were concerned about upstanding citizens leaving Leavenworth because of its saloons and whorehouses and signed a petition to "either abolish from the town a certain class known as 'sporting women,' or restrict them to a section of the town out of the business portion and off the main street." The city council actually turned it down. This church building served its members for 41 years until a new church was built at the corner of Evans and Summit Streets in 1948. (Courtesy of the Upper Valley Museum at Leavenworth.)

During the early days of Leavenworth, men rode on "iron horses" and on flesh-and-blood horses. The photograph above is of two gentlemen posing in front of one of the Great Northern Railway's locomotives in the divisional yard at Leavenworth. Note the pivoting smokestack that was used to divert smoke backward during travel through the Cascade Tunnel. The gentlemen below, from left to right, are Jack Roth, George Shugart, Frank David, and Noble L. "Dude" Brown. Brown served as Leavenworth sheriff for a number of years during the early Wild West days. George Shugart homesteaded in Plain in 1911, some 13 miles north of Leavenworth. (Above, courtesy of Bill Haines; below, courtesy of the Upper Valley Museum at Leavenworth.)

Almost every homesteader in Leavenworth and the surrounding areas had a garden and fruit trees. Tree fruit growers were successful in Icicle Valley and greater Leavenworth areas due to the advent of irrigation. Apple orchards in the higher elevations were not as successful as those in the lower elevations, but pears did quite well. Fruit trees flourished on the sunny slopes of the Ski Hill area until the housing boom in the 1990s. In this c. 1930 photograph, Reg Parsons is seen in his orchard on North Road in Leavenworth. Many orchards remain in this area today, but more and more farmers are choosing to grow wine grapes. Today Leavenworth is considered part of Washington Wine Country. Some of the grapes used are grown in the immediate vicinity and some are grown farther east. (Courtesy of the Wenatchee Valley Museum and Cultural Center No. 003-77-5.)

Fruit growing, along with railroading and the local sawmill, made Leavenworth a boom town almost overnight. The early 1940s photograph above shows children posing in the Parsons orchard with stacks of wooden apple boxes. They were constructed of wood for many years, but in the late 1950s the switch was made to cardboard, which was easier to handle and also easier on the fruit. The photograph at left is of the fruit packing warehouse in Leavenworth. A worker is seen on the back of a flatbed truck using a hand truck to unload full boxes of fruit. Currently the whole Wenatchee Valley is one of the nation's foremost fruit-growing regions thanks to the water carried via irrigation ditches and canals from the Icicle watershed. (Both courtesy of the Wenatchee Valley Museum and Cultural Center No. 003-77-14 and No. 003-77-12.)

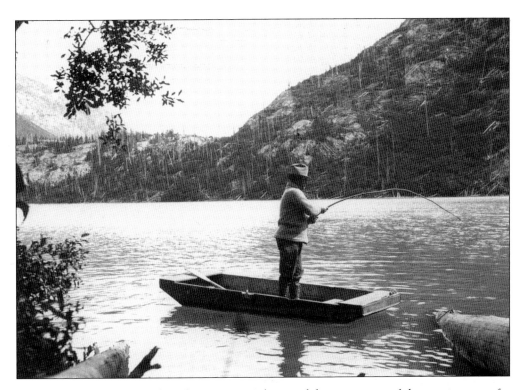

When pioneers first arrived in the Leavenworth area, fishing was one of the requirements for their survival. In later years, residents no longer depended on fishing for basic survival. To this day, fishing is a popular recreational activity. Leavenworth provides many outstanding spots for residents and visitors alike to relax and enjoy a day of fishing. The above photograph shows a man fishing from his rowboat on Lake Wenatchee. The photograph below shows a family paddling on a pond at Tumwater Campground, located in Tumwater Canyon along the Wenatchee River. Note the young angler on the left. (Both courtesy of the U.S. Forest Service.)

The Cougar Inn, seen here in 1927, was once owned by Oliver and Sally Bates. They purchased a large tract of land and built the Lakeview Lodge hoping to cash in on the building of the Great Northern Railway through the Chumstick Valley. They lost out when the Great Northern chose a slightly different route, so they sold the hotel in 1922 to William A. "Cougar Bill" Smith, who renamed it the Cougar Inn. The *Leavenworth Echo* reported in June 1922 that the opening of the inn "was attended by the largest crowd ever gathered at Lake Wenatchee and a good time is reported by those present." Dances were commonly held there on Saturdays during the summer months. According to legend, one day Smith walked out his back door to go fishing and was never seen again. His ghost has allegedly haunted the place since then, but his ghost is said to be friendly and apparently never causes trouble. (Courtesy of Bill Haines.)

Frances and Burt Gutherless, not to be confused with J. E. Gutherless who was mayor of Leavenworth from October 1909 to December 1910, were early residents of Leavenworth. Above they are seen posing in front of Dr. George W. Hoxsey's cabin. Hoxsey was the physician sent to Leavenworth to care for the Great Northern Railway workers. Burt and Frances were both active in the community and loved the great outdoors. At this time in Leavenworth's history, people from near and far came via the Great Northern Railway to enjoy the area's vast recreational opportunities. Hiking and fishing were among the most popular activities. The Mountaineers, a Seattle-based organization that promoted exploration of the surrounding wilderness areas, planned trips to the Leavenworth area to explore the beautiful Cascade Mountains. Their 13th annual outing was in the Glacier Peak wilderness in August 1921. (Courtesy of Bill Haines.)

Frances and Burt Gutherless pose on the front porch of their home for this photograph. They were married in 1911. Burt was a civil engineer for the Great Northern Railway and Frances was employed as a schoolteacher. They lived just outside Leavenworth in a Great Northern Railway camp but later moved into town. They had two children, Wanda and Wilma. The brick home seen in both of these photographs was their temporary home on Cedar Street. The bricks the home is built of likely came from the brickyard of J. E. Gutherless, which he began running in 1908. (Courtesy of Bill Haines.)

This whimsical photograph shows Frances Gutherless mending the torn back pocket of her husband's overalls. Burt, a civil engineer for the Great Northern Railway, designed the pedestrian viaduct over the railroad tracks. About 25 locomotives passed through the downtown tracks each day, causing the residents of Leavenworth concern for the people who had to cross the tracks on a daily basis, namely the schoolchildren in town. The high wooden overpass was built in 1906 and was replaced in 1909 after a spectacular wreck demolished the first one. The home in which Burt and Frances are posing is located on Cedar Street. (Courtesy of Bill Haines.)

PATH OF AVALANCHE AT WELLINGTON, WN. MARCH 1, 1910. J.D. WHEELER- 1118 LEAVENWORTH, WN.

On March 1, 1910, one of the worst rail disasters occurred in the little town of Wellington, nestled deep in the Cascade Mountains. This disaster greatly affected the Great Northern Railway hub town of Leavenworth. Two westbound trains, a passenger train, and a mail train bound for Seattle from Spokane, were stalled in Wellington due to heavy snowfall. Blizzard conditions ensued and when the snow turned to rain with thunder and lightning, the worst avalanche in Washington State history barreled down from the peak of Windy Mountain onto the town of Wellington. The two stalled trains were crushed. Ninety-six people died in the avalanche. The *Leavenworth Echo* later reported that at least 100 people from Leavenworth rushed to the aid of the victims. Wellington was renamed Tye in October 1910 due to the associations of the old name, and in 1913, concrete snowsheds were constructed to offer protection from further slides. (Both courtesy of Bill Haines.)

The Tumwater Canyon was exciting to travel through in the best of times, but when snowstorms hit, travel was slow and treacherous. Rotary snowplows worked the whole canyon to clear the tracks, sometimes proving disastrous. This snowplow met its end in February 1916. (Courtesy of the Upper Valley Museum at Leavenworth.)

"Great Northern Troubles in Tumwater Canyon" is written at the bottom of this 1916 photograph taken by Leavenworth photographer J. D. Wheeler. Scenes like this became common and costly for the Great Northern Railway to deal with, causing the railway company to make the tough decision to relocate the tracks through the Chumstick Valley in order to avoid the hazardous Tumwater Canyon. (Courtesy of the Upper Valley Museum at Leavenworth.)

In the winter of 1916, Leavenworth and the surrounding areas received an astounding 21 feet of snow, as seen in these two photographs. The above photograph was taken along Front Street and the photograph below was taken in an alleyway. Deep snow on the tracks and frequent slides occurred in the Tumwater Canyon and elsewhere along the Great Northern Railway route through the Cascade Mountains. In 1925, after the Great Northern decided to relocate the tracks through the Chumstick Valley, it resolved to abandon the divisional yard in Leavenworth, moving it to Wenatchee. That, combined with the closure of the Lamb-Davis sawmill in 1926, was the beginning of the decline of the town of Leavenworth. (Both courtesy of Bill Haines.)

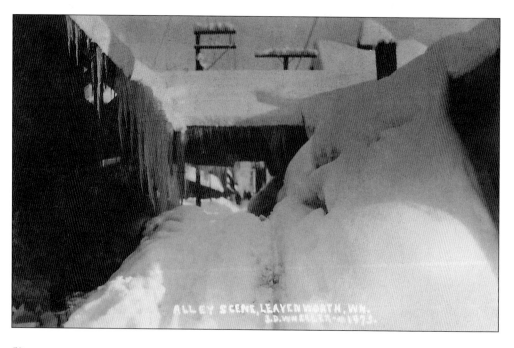

Town banker R. B. Field and his wife, Frances, pose next to their home located along the Wenatchee River. They lived there from 1921 to 1967. Prior to their ownership, it was known as the Lamb-Davis bungalow, serving as the summer home of Lafayette Lamb, president of the Lamb-Davis Lumber Company. Many people have owned it since and it was even a bed and breakfast, called Haus Lorelei on the River owned by Elisabeth Saunders. When she decided to sell, noted philanthropist Harriet Bullitt and the Icicle Fund donated the money to purchase the house. When E. Lorene Young, pictured below, bequeathed her adjacent property to the Chelan Douglas Land Trust, it expanded the property by 3.5 acres. She was the first and only female mayor of Leavenworth, holding office from November 1979 to December 1983. (Right, courtesy of the Upper Valley Museum at Leavenworth; below, courtesy of the *Leavenworth Echo*.)

R. B. Field, who established the Leavenworth State Bank in 1920, was quite fond of Arabian horses. He is pictured here in this c. 1948 photograph with his horse Marobi in the corral of the Bent River Arabian Ranch, which was below and adjacent to his home. The Field family raised champion horses on this land. When he passed away in 1967, his daughter lived there until later that year when it was sold. Some of the most notable owners have been Carolyn Schutte, who donated what is now Waterfront Park to the city, and Ted Price and Bob Rodgers, who were leaders in the effort to transform Leavenworth into a Bavarian-themed village. The current Barn Beach Reserve, named after the horse barns of the Bent River Ranch, occupies the property and the Upper Valley Museum and Icicle Arts are the current inhabitants of the house, located uphill from the Bent River Ranch. (Courtesy of the Wenatchee Valley Museum and Cultural Center No. 005-72-3.)

The summer of 1925 was an exciting time for the residents of Leavenworth and the surrounding areas. The Famous Players-Lasky Corporation, producers for Paramount Pictures, filmed the silent movie *The Ancient Highway*. This film was based on the novel by James Oliver Curtwood. Stars Jack Holt and Billie Dove attracted spectators from far and wide. Many locals served as extras, and loggers from the Rider Lumber Company even staged a realistic fight scene for the cameras. Scenes were filmed in the valley and also the Chiwawa River. At right, film crews can be seen working under umbrellas and Billie Dove's chair can be seen in the foreground. Below Jack Holt paddles along the Chiwawa River in this publicity photograph. (Right, courtesy of Bill Haines; below, courtesy of Bruce Calvert.)

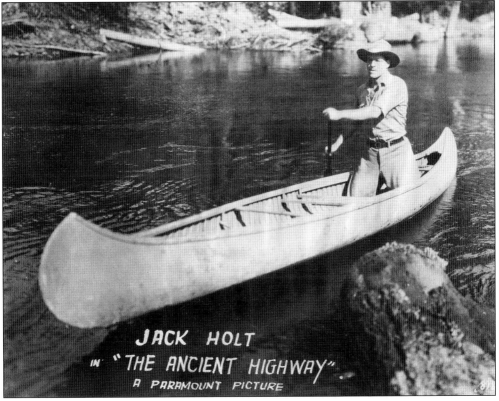

JACK HOLT IN "THE ANCIENT HIGHWAY" A PARAMOUNT PICTURE

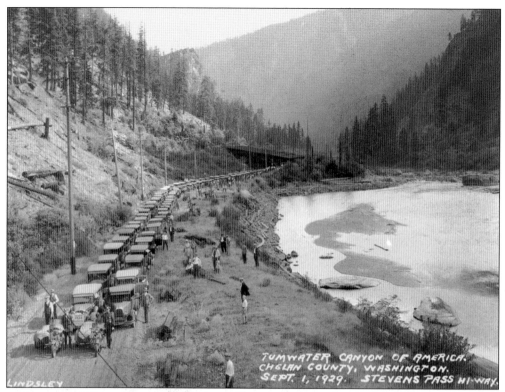

Tumwater Canyon of America. Chelan County, Washington. Sept. 1, 1929. Stevens Pass Hi-Way. Lindsley

Tumwater Canyon

Tourism was an industry the residents of Leavenworth wished to develop, and this required a passable route between the west side and east sides of the Cascade Mountains. Key citizens began meeting and planning a route in 1911, but when World War I broke out, the work was postponed. In 1922, hotel owner H. B. Smith renewed his lobbying for a drivable route through the Cascade Mountains. After many meetings and much work with the U.S. Forest Service, the Stevens Pass Scenic Highway officially opened on July 11, 1925. The highway followed the old abandoned rails through the Tumwater Canyon, as seen in these two photographs. The above photograph was taken in September 1939. A remaining snowshed is visible in the distance. The photograph at left is of a carless version of the highway. (Above, courtesy of the U.S. Forest Service; left, courtesy of Bill Haines.)

Three

FOREST SERVICE

The first Wenatchee National Forest headquarters was on Commercial Street in Leavenworth in 1908. A. H. "Hal" Sylvester was the first supervisor. The headquarters was moved to Wenatchee in 1921, but the Leavenworth Ranger Station remained in town, employing many people in the area. The above photograph was taken in the winter of 1908. (Courtesy of the U.S. Forest Service.)

Hal Sylvester poses for this photograph with his wife, Alice. Born in 1871, he was a pioneer explorer and served as the first Wenatchee National Forest supervisor when it was formed in 1908. He was a topographer for the U.S. Geological Survey in the Snoqualmie Ranger District from 1897 to 1907. He is most known for detailed surveying and place naming, giving names to more than 1,000 natural features within the Wenatchee National Forest. Many of the names he chose were purely creative, such as Labyrinth Mountain with Minotaur and Theseus Lakes located on the mountain. Other names had personal significance, such as Lake Alice, named for his wife, and Lake Augusta, named for his mother. Other duties included mapping, building trails, and fire lookouts. He was mortally wounded in 1944 while leading a group of friends to one of his favorite places in the Cascades when his horse startled and lost its footing on a steep and rocky slope. He was rescued and taken to a hospital in Wenatchee where he died of his injuries. (Courtesy of the U.S. Forest Service.)

Early fire detection was a critical aspect of forest management. The photograph at right is of the fire lookout on Dirtyface Peak rising over the west edge of Lake Wenatchee in 1943. This was not the original lookout; its location was established with a camp in 1914 and this structure was built in 1933. It was replaced in 1957 with the structure shown below. In 1975, it was scheduled to be relocated by helicopter; however, the helicopter was unable to lift it, so it was burned to the ground instead. The peak's name is somewhat of a local legend. It is named for a homesteader in the late 1800s who worked avidly clearing his land. Locals often found him with a sweaty, dirty face, so he was nicknamed "old dirty face," hence the naming of the peak behind his homestead. (Both courtesy of the U.S. Forest Service.)

In 1905, the U.S. Forest Service hired men as "forest guards," but in 1909 the forest service offered a civil service exam specifically for the post of forest ranger. The photograph at left is of foresters working in the Wenatchee National Forest. Jobs for these men at first included checking up on homestead claims. Later they had duties such as fire detection and fighting, creating trails in order to reach fires, and managing grazing permits to avoid overgrazing in forestlands. In 1919, the *Leavenworth Echo* estimated that there were a quarter million sheep in the Wenatchee and Chelan forests. Sheep grazing was useful for keeping unwanted brush growth down, but there was the added risk of carrying vermin into the forestlands, which spread to the wild animals there. The photograph below is of sheep grazing in the Wenatchee Ranger District in 1930. (Both courtesy of the U.S. Forest Service.)

Since creation of the Civilian Conservation Corps, known as the CCC, in 1932, the U.S. Forest Service employed those young men to work on various projects within forestlands. They were instrumental in diminishing the destruction caused by forest fires and they also worked on other projects, including mapping and surveying and thinning timber stands in forestlands. The CCC boys were instrumental in the construction of the Pacific Crest Trail, a trail running the length of the Cascade Mountains' crests from Mexico to Canada. The young man seen above was photographed constructing a pipeline, most likely to carry water, and the men seen below were photographed while building a rockery wall at the Leavenworth Ranger Station in 1936. (Both courtesy of the U.S. Forest Service.)

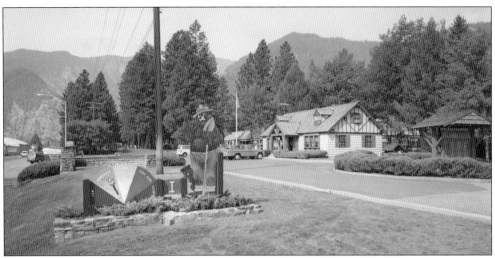

In 1921, the headquarters of the Wenatchee National Forest relocated to Wenatchee but the Leavenworth, Lake Wenatchee, and Cashmere ranger districts continued to provide year-round and seasonal employment to citizens in the area, especially since timber cutting was allowed on forest lands from the early 1930s to the late 1950s. In 1938, a new ranger station was built. The original plans were for a four-room office facility, but in 1964 a T-shaped, one-story addition was constructed onto the north side. The photograph above was taken from the southeast side and the photograph below is a close-up of the entryway. When Leavenworth adopted its Bavarian theme, the modifications were easy for the forest service since the building was originally timbered. (Both courtesy of the Library of Congress Prints and Photographs Division, HABS, Reproduction numbers HABS WASH,4-LEAVNO,1A-2 and HABS WASH,4-LEAVNO,1A-9.)

Four

CAMP ICICLE

In 1932, Pres. Franklin D. Roosevelt created the Civilian Conservation Corps, which provided employment to approximately 275,000 young men across the country. The photograph above is of Camp Icicle, established in 1933. It was one of the four major Civilian Conservation Corps camps in Central Washington and is the present site of the Sleeping Lady Mountain Retreat. (Courtesy of the U.S. Forest Service.)

Camp Icicle was home to the 983rd Company Civilian Conservation Corps (CCC) and employed approximately 226 young men who came from all parts of the United States, some of whom are seen in the above photograph from around 1935. They were trained by the government in building, mapping and surveying, thinning timber, firefighting, and road and bridge construction. Those Depression-era workers are credited for building many of the structures on forest service land today, such as the Ski Hill Lodge and forest service fire lookout towers. The "higher-ups" posed for the photograph below. Standing, from left to right, are educational advisor Keller; superintendent Joe Guiberson; Doc Martin, M.D.; General Stone; Major Hirsch; and Lieutenant Brown, who was second in command. (Both courtesy of the Wenatchee Valley Museum and Cultural Center No. 003-82-50 and No. 003-82-50.)

Many of the CCC enrollees had no formal education beyond eighth grade. Enrollment or enlistment lasted six months with an option of reenrolling for additional six-month periods for a maximum of two years. They attended classes in forestry, geology, mechanics, radio technology, math, grammar and spelling, and first aid—opportunities they normally would not have had during the Great Depression era. They were encouraged to pursue recreational activities, which often involved competitive and organized sports. The football team of 12 players pictured above posed wearing their numbered jerseys in 1936. Pictured, from left to right, are (first row) Robert G. Glenn, Robert Whannell, Wallace Anderson, Walter Brady, Holden and Roy Hatmaker; (second row) Arthur Brooks, John Harter, Alden S. Mugrage, Howard Davis, Fred Word, and Floyd I. Craig. (Courtesy of the Wenatchee Valley Museum and Cultural Center, No. 003-92-10.)

Noted on this photograph is "Baseball spring of 1936." In the CCC, men spent their leisure time enjoying baseball, football, swimming, volleyball, horseshoes, boxing, and musical jam sessions. Recreation was important, but the men also enjoyed working in the great outdoors. The names of the players are written on the back of the photograph. Pictured, from left to right, are (first row) Walter Brady, Stemkoski, Sullivan, Johnson, Dean H. Finley, Ammie Carl, and Wallace Anderson; (second row) Owens E. Williams, Ralph Van Schoiach, two unidentified, Berg, John Bullo, and Thacker. They posed for this photograph in front of a CCC cabin. Originally there were no buildings, only rows of tents. Buildings were constructed a few years after the camp was established in 1933. (Courtesy of the Wenatchee Valley Museum and Cultural Center, No. 003-82-1.)

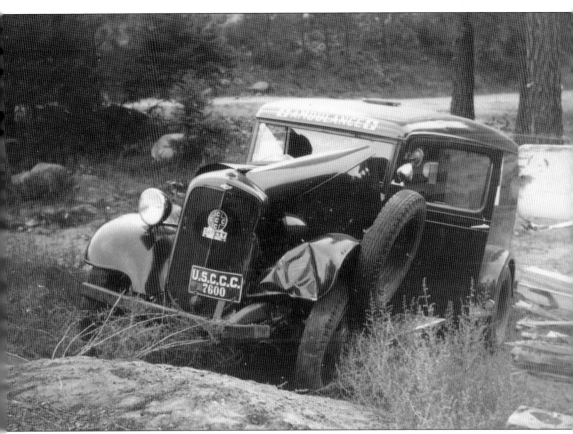

The Chevy in this 1936 photograph was identified by markings to be a Civilian Conservation Corps ambulance. It was found in the forest with a crumpled front left fender. The front license plate reads "U.S.C.C.C. 7600." In June 2004, one of the CCC men commented on the wreck: "A dance was held in Leavenworth, possibly at the Grange Hall. The driver of the camp ambulance went and got 'snorkeled.' Driving back to the Icicle Camp he didn't make the road's dip and sharp turns and wrecked before crossing the Icicle River bridge. The driver did not report the next morning. The ambulance was found and a search was made along the Icicle River thinking the driver may have been washed away. He was later discovered in another part of the state claiming he totally blacked-out and didn't remember how he got there." (Courtesy of the Wenatchee Valley Museum and Cultural Center No. 003-82-19.)

According to a March 2008 article in *Forest Service Today*, some racially integrated camps existed but these were disbanded in 1935. Documentation shows this photograph of two men leaning together with bottles was taken between 1936 and 1939, so it is somewhat of a puzzle. From left to right are Schafer and Reed. According to the above-mentioned article, "By 1938 the number of African-American enrollees reached 10 percent, and by the end of the program nearly 250,000 served, almost all in segregated camps." Recreation was important but the forestry work was more so. The CCC was responsible for forest management, which meant thinning timber stands and cutting trees to be used in projects. The photograph below shows two men using axes to peel logs, perhaps for telephone wire poles. (Left, courtesy of the Wenatchee Valley Museum and Cultural Center No. 004-27-1.13; below, courtesy of the U.S. Forest Service.)

The 983rd Company of the Civilian Conservation Corps Camp Icicle F-29 remained until 1946. The next people to occupy the land were Winifred and Geri Davy when they bought it and transformed it into a dude ranch. They called it Icicle River Ranch, and it could host as many as 400 guests and offered high country adventures. When the ranch eventually closed, R. B. Field of the Leavenworth State Bank bought the property to pasture some of the Arabian show horses from his Bent River Ranch. In 1957, Field donated the property he owned to the diocese and it was named Camp Field. Several bunk houses were built, as was a chapel. This photograph is of the chapel theater built sometime in the late 1950s to the early 1960s. Camp Field was used as a Catholic youth organization for boys and girls until 1992. Fr. Joseph O'Grady was the director of Camp Field. (Courtesy of the Sleeping Lady Mountain Resort.)

In 1992, Harriet Bullitt purchased the land from the diocese initially to keep anyone from ruining it. The Bullitt family had owned the adjoining property and Harriet was known to enjoy many summers and holidays at her family's place off Old Bridge Road. Eventually she created a conference retreat center known as the Sleeping Lady Mountain Resort where groups and individuals are welcome to stay and dine on gourmet meals that can be enjoyed in the Kingfisher Dining Lodge. The Sleeping Lady got its name from the mountain profile rising above the valley, which looks like a woman lying on her back, as seen in these photographs. Harriet's strong commitment to the environment prompted her to preserve and enhance the naturally serene setting. No trees were taken down if at all possible and many other trees were planted. (Above, courtesy of the Leavenworth National Fish Hatchery; below, author's collection.)

Five

FISH HATCHERY

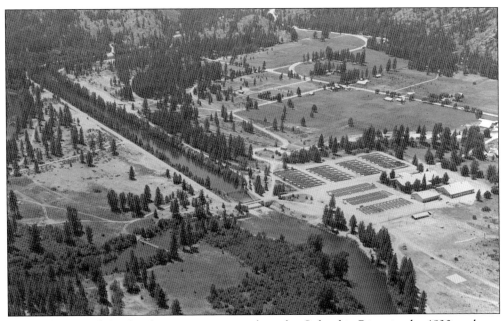

When the Grand Coulee dam was constructed on the Columbia River in the 1930s, salmon migration above the dam was brought to a halt. Through the efforts of the U.S. Bureau of Reclamation and state and federal fisheries, the Leavenworth National Fish Hatchery, shown above, was largely completed by 1940. (Courtesy of the Leavenworth National Fish Hatchery.)

The engineers and planners of the hatchery knew the facility would require cold, clear water to keep the waters at the hatchery at the optimal temperature during the hot summer months. A trail for pack animals was constructed and a camp at Nada Lake high upstream near the headwaters of Snow Creek, a tributary to the Icicle River, was completed. The camp consisted of dormitories, a mess hall, a cook shack, a compressor house, a blacksmith shop, and a powder shed. The packers were employed by the packing outfit Barnett and Creveling, and they were tasked with blasting a tunnel from the bottom of Snow Lake and constructing a valve to control water flow to Nada Lake, which would then cascade into the Icicle River. In October 1938, Barnett and Creveling began sending packers, such as Haven Stanaway pictured above, to the Nada Lakes camp. Once the project was completed, the valve was opened each year in the late summer to supply cold water for the salmon at the hatchery. (Courtesy of the Leavenworth National Fish Hatchery.)

The above photograph shows a winter pack train in action. These men, who were part of a 40-man crew, were responsible for packing machinery to the Nada Lake camp. Some of the equipment had to be disassembled for the steep climb. The tunnel blasted was some 2,500 feet in length and around 7 feet in diameter. Periodically the elevation of the water surface at Upper Snow Lake was checked so as not to over-drain the lake. Thirty-inch gate valves controlled the release of the lake water. This reservoir system is still in use today, keeping the salmon at the hatchery cool during the hot summer months. (Both courtesy of the Leavenworth National Fish Hatchery.)

The construction of the fish hatchery included buildings, dams, and flood channels. The above photograph, taken in February 1940, is of the main hatchery building. It measured 225-by-88 feet and had two additional wings of 36-by-45 feet providing enough room for administration and storage. The Leavenworth National Fish Hatchery Complex's administrative center was in Leavenworth. Satellite hatcheries belonging to the complex as a whole were constructed in Entiat and Winthrop. At the time, this complex was the world's largest. The December 1939 photograph below is of the spillway dam during construction. (Both courtesy of the Leavenworth National Fish Hatchery.)

Thousands of feet of irrigation pipe were laid during the construction of the Leavenworth National Fish Hatchery to provide water to the facility. The photograph at right is a representation of what the work looked like in March 1940. Note the hatchery buildings on the right-hand side in the distance. The timing of the construction of the hatchery could not have been better; Leavenworth was reeling from the Great Depression, the loss of the Great Northern Railway hub, and the loss of the Lamb-Davis sawmill. The work at the hatchery provided jobs for many people who lived in town and the surrounding area. (Both courtesy of the Leavenworth National Fish Hatchery.)

The hatchery was in full operation in this 1947 photograph, which shows the hatchery building and ponds in the foreground. Maintaining the facility was always important. Note the sawhorses with construction material next to the ponds. The Sleeping Lady Mountain profile rises in the distance, covered with a halo of clouds. The May 1940 photograph at left shows the interior of the hatchery building during construction and inspection of the hatching troughs in the nursery. The indoor hatching troughs were ideal for egg incubation and rearing of salmon fry because the nursery building was safe from potential predators and was plumbed with groundwater, which provided a more suitable water temperature that was free of pathogens. (Both courtesy of the Leavenworth National Fish Hatchery.)

The hatchery complex was constructed as fish mitigation facilities for the construction of the Grand Coulee Dam, built in the 1930s. The primary mitigation species was the spring Chinook salmon. The initial plan in the 1940s called for adult spring Chinook salmon to be trapped at Rock Island Dam, which was the first dam spanning the Columbia River built between 1829 and 1933, and trucked to the Leavenworth hatchery for spawning. The first step requires work in the hatchery, as seen in the photograph at right of the gentleman measuring salmon eggs. Those eggs are fertilized and kept in trays until the fish hatch in October. The photograph below is of a woman marking fish before their release into the Icicle River. The data would be recorded on the salmon runs later. (Both courtesy of the Leavenworth National Fish Hatchery.)

Over the years, the hatchery production program has included a multitude of species, including spring and summer Chinook salmon, Coho salmon, steelhead, and Kokanee, with the primary species being the spring Chinook. The site looks very different today from the December 1940 photograph above. One of the primary changes in the landscape is the addition of shelters over the concrete ponds and raceways to keep predators out. In 1998, the Leavenworth National Fish hatchery was placed on the National Register of Historic Places by the U.S. Department of the Interior because of the historic significance of its construction in 1939 and for its contribution to the conservation of salmon. The plaque pictured below hangs just outside the front doors of the main hatchery building today. (Above, courtesy of the Leavenworth National Fish Hatchery; below, author's collection.)

LEAVENWORTH NATIONAL
FISH HATCHERY
HAS BEEN PLACED ON THE
NATIONAL REGISTER
OF HISTORIC PLACES
BY THE UNITED STATES
DEPARTMENT OF THE INTERIOR
1939

Six

SKI HILL

In the 1920s, settlers developed a small ski area with a toboggan run and a small ski jump on Wheeler Hill on the northern outskirts of Leavenworth. Through the years, the Leavenworth Ski Hill has become quite popular. These lovely ladies posed with their skis among the hundreds of Ski Hill visitors. (Courtesy of the University of Washington Libraries, Special Collections, Pickett 4710b.)

Ski tournaments were held in February from the early 1930s until the mid-1970s. The fame of Leavenworth's ski jumping tournaments brought thousands of visitors from around the state. Some of the spectators rode special "ski trains" from Seattle to Leavenworth and then were shuttled to the ski hill from across town. The ski tournaments in the 1930s drew increasingly large crowds, a

boon to the depressed Leavenworth economy. The tournament of 1937 attracted 1,800 people by train alone. This photograph shows skiers and spectators lined up along the edge of the ski hill. The popularity of the ski tournaments increased the popularity of the Leavenworth Ski Hill venue itself. (Courtesy of the University of Washington Libraries, Special Collections, PIC1283.)

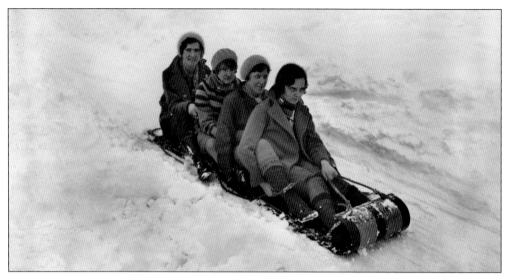

Toboggan runs, constructed by volunteers, were a popular attraction at the Leavenworth Ski Hill. The women in this action shot above were enjoying a bit of sledding, though the woman in front looks a little more apprehensive than the woman in the back. This photograph, as well as the photograph of three gentlemen skiers, was taken by Michigan-born Lee Pickett. He was a photographer for the Great Northern Railway during the 1920s, documenting improvements in the line. After the project was completed, he returned to freelance work. He took many photographs of the Leavenworth Ski Hill, capturing moments like this for posterity. (Both courtesy of the University of Washington Libraries, Special Collections, Pickett4693a and 4694.)

The Leavenworth Ski Hill lodge, as seen in the bottom-left corner of this photograph, was built between 1935 and 1936 by Civilian Conservation Corps employees. It is still standing today, though the ski hill does not draw the crowds it once did. Ski jumping tournament weekends were the social highlight in the late 1930s to the early 1940s. As many as 10,000 visitors could be expected on these weekends and dances were usually held on Saturday. Everyone chipped in to groom the hill and prepare food. This venue was once deemed one of the finest in the northwest circuit and ski jumpers from all over the world made the trek to Leavenworth. The national ski jumping championships were held here in 1955 and the town was ecstatic about this televised event. The Leavenworth Winter Sports Club, which was established in 1928, is still going strong today and is not only dedicated to skiing, but to Leavenworth's rich ski heritage as well. (Courtesy of the Wenatchee Valley Museum and Cultural Center, No. 78-208-19.)

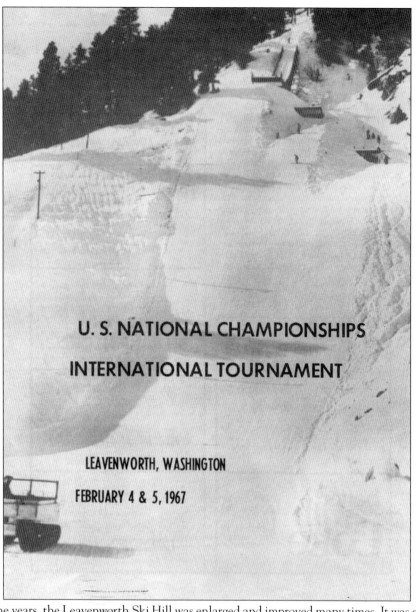

U. S. NATIONAL CHAMPIONSHIPS

INTERNATIONAL TOURNAMENT

LEAVENWORTH, WASHINGTON

FEBRUARY 4 & 5, 1967

Over the years, the Leavenworth Ski Hill was enlarged and improved many times. It was gaining a fantastic reputation, so much so that it hosted the U.S. National Championships in 1941, 1959, 1967, 1974, and 1978. The cover of the 1967 program is pictured above. Though the Leavenworth Winter Sports Club was still going strong, tournaments declined in the 1970s with the construction of newer and larger ski jumps throughout the country in places such as Steamboat Springs, Colorado, and Iron Mountain in Michigan. The ski club tried to resurrect interest with the planned construction of two new ski jumping hills from 1986 to 1988, but unfortunately, this did not repeat the popularity of the old days. Leavenworth has been home to world-class U.S. Olympic team athletes such as Ron Steele—the best-placed American jumper in the 1972 Olympics in Sapporo, Japan—and Nordic skier Torin Koos, who competed in the 2002, 2006, and most recently, the 2010 Olympics that were held in Vancouver, British Columbia. His home ski club is the Leavenworth Winter Sports Club. (Courtesy of Ann Ostella.)

The sport of ski jumping was rather new when Magnus and Hermod Bakke arrived in Leavenworth in the 1930s. The Bakkes were instrumental in transforming the Leavenworth Ski Jumping Tournament into one of the top sports attractions in not only the Pacific Northwest, but the entire United States. Posing in the November 1966 photograph at right, from left to right are Gene Buchanan, Hermod Bakke, and Ralph Steele. They were working on the new ski building, which housed the ticket office and the ski clubroom. The big ski jump was eventually named Bakke Hill, seen in the photograph below. The Bakkes were inducted into the National Ski Hall of fame in 1972. (Both courtesy of the *Leavenworth Echo*.)

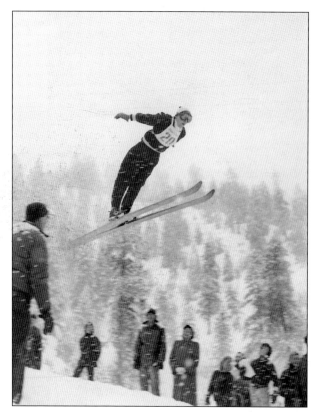

Local ski jumper Clarence Ostella was an active participant in the ski jumping community. He is seen in these two photographs in mid-flight. He participated in tournaments for many years, then in the 1960s he was the chief of competition for several tournaments. During the tournaments, spectators stood along both sides of the run, vying for the best viewing position located just below the lip of the jump ramp where skiers can be seen up-close just as they take off, as seen in the photograph at left. The judging team watched from the stands, as seen in the photograph below. (Both courtesy of Ann Ostella.)

The above photograph is a skier's-eye view looking toward the two ski jumping runs. Though the longer Bakke Hill run is no longer in use, the smaller D hill run is. An attempt to revive ski jumping in Leavenworth was made recently with the first Bakke Cup in January 2010. Hermod Bakke competed as a Class A ski jumper for many years. He was also an excellent cross-country skier. He was a hands-on ski hill designer; he redesigned the big hill at the Leavenworth Ski Hill. He served as tournament chairman or chief of hill from 1932 to 1969. He was a well-known supporter of ski jumping in Leavenworth, and through his efforts and the efforts of his brother Magnus, skiers of all ages enjoy the Leavenworth Ski Hill. They were inducted into the Ski Hall of Fame in 1972. (Courtesy of the Upper Valley Museum at Leavenworth.)

The jumpers in this 1968 photograph were waiting for their turn to try for new ski jumping records. It was reported by the *Leavenworth Echo* that the 1968 tournament was plagued by windy conditions. The wind was so gusty that the 90-meter hill could not be used. The competition was held on the 40-meter hill instead. The 1967 tournament record was held by Björn Wirkola from Norway who jumped 335 feet. That record would not be broken until 1970 when Greg Swor from the United States jumped an astonishing 345 feet, a record which still stands to be broken. At this time, the Leavenworth Ski Hill was regarded as one of the premier ski jumping venues in North America. During the tournaments of the 1960s, people flocked to town on trains and in cars to see competitors from Canada, Norway, and the United States. Parking was excellent at Leavenworth Ski Hill; there was room to park 3,000 cars. Free transportation was also offered from the parking lots in Leavenworth. Lodging was not plentiful at this time, so planning ahead was a must. (Courtesy of the *Leavenworth Echo*.)

The windy conditions of the 36th annual ski jumping tournament in 1968 were an obvious cause for concern. The Class A jumpers seen above were photographed while discussing the wind conditions with tournament chairman Clarence Ostella, the gentleman with his back to the camera. It was decided the show would go on and it did, but not without injury. A skier was injured on the final jump on the 90-meter hill. He suffered a spinal injury and was partially paralyzed. A week later, when it was not so windy, the beginners' ski jumping meet was held. The proud winners are pictured below. They are, from left to right, (first row) Mike Brown, Chris Ostella, Don Alexander, and Will Henson; (second row) Randy Alexander and Robert Ferrell. (Both courtesy of the *Leavenworth Echo*.)

Ski Hill not only attracted Class A competitors, as seen in the photograph at left, but junior competitors as well. In 1968, junior expert Marc Buchanan jumped a spectacular 167 feet on the 40-meter hill and his brother took junior novice honors by jumping 106 feet on the same hill. The building above the Bakke Hill signage used to be open stands, but it was enclosed for the comfort of the judging crew. The junior skiers below posed while showing off their trophies and ribbons. They had to compete in downhill, giant slalom, cross-country, and jumping. Tracy Ostella, daughter of Clarence and Ann Ostella, is second from the right. Junior ski meets are making a resurgence; the first Bakke Cup was held in January 2010 with competitions in ski jumping, alpine skiing, and cross-country skiing. (Left, courtesy of the *Leavenworth Echo*; below, courtesy of Ann Ostella.)

Seven

L.I.F.E. IN LEAVENWORTH

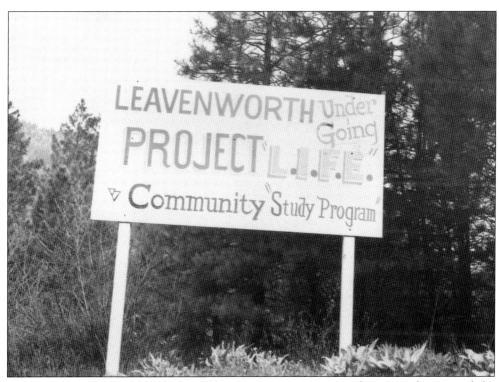

Leavenworth in 1960 was dubbed a welfare town. Businesses were closing one by one and the town's economic condition was dire. In 1962, the chamber of commerce, knowing something had to be done, contacted the Bureau of Community Development at the University of Washington and Project L.I.F.E— Leavenworth Improvement for Everyone—was born. (Courtesy of the Wenatchee Valley Museum and Cultural Center, No. 003-60-19.)

In 1960, Ted Price and Bob Rodgers purchased the Coles Corner Cafe in the Lake Wenatchee area on U.S. Highway 2. They chose a Swiss Bavarian theme and poured every resource into the project. The Squirrel Tree restaurant was born. The advertisement at left appeared in the *Leavenworth Echo* in 1964. (Courtesy of the *Leavenworth Echo*.)

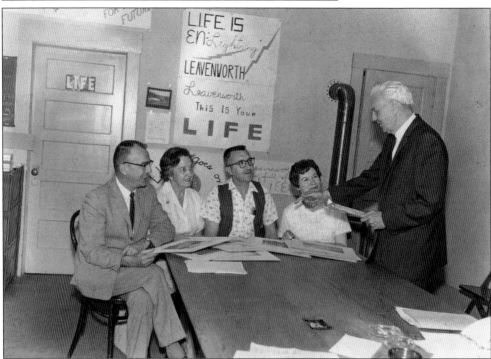

With the success of the Squirrel Tree, Price and Rodgers began to ponder what would happen if Leavenworth adopted a similar theme. Project L.I.F.E. began in 1962 and was intended to revitalize the town. In 1963, KING TV of Seattle sent a crew to film a recreation program in the area and L.I.F.E. meetings were also included. Above, from left to right, are Robert Brender, Margaret Motteler, Lee Lepper, Vi Standish, and Richard Weir, who are practicing for the television show. (Courtesy of the Wenatchee Valley Museum and Cultural Center, No. 003-60-171.)

During a L.I.F.E. meeting on June 15, 1964, it was decided that adopting a Bavarian theme for Leavenworth was feasible. Some folks objected and a heated discussion occurred before the decision. The above photograph of Leavenworth business owner Pauline Watson appeared in the *Leavenworth Echo* on June 17, 1965, along with the headline "Leavenworth Goes 'Alpine:' Bavarian Alpine Store Fronts Are Favored." She was so enthusiastic about the project that she drew sketches of some of the storefronts downtown, one of which is seen below. She and Bob Rodgers presented the sketches at a meeting of approximately 20 people at the Tumwater Cafe on June 10, 1965. Every person present consented to the Bavarian remodel. (Above, courtesy of the *Leavenworth Echo*; below, courtesy of the Upper Valley Museum at Leavenworth.)

In the 1900s, this building was known as the Barclay Hotel and was owned by A. C. Barclay. He was a conductor for the Great Northern Railway. In 1937, it was sold to Henry Hagman. Later it was sold to Vern and Ann Herrett and it was one of the first six buildings remodeled to reflect the Bavarian theme. It was, and still is, one of the tallest buildings on Front Street. These two photographs show the progression of the construction work during 1966. Note the addition of decorative painting and window boxes. Details such as this were added to every shop remodeled. Many businesses such as lodging, women's furnishings, jewelers, and even a beauty shop operated out of this building. The Public Utilities District (PUD) office was in the front to one side during the 1950s and a dental office was on the other from 1930 to 1969. (Both courtesy of the Upper Valley Museum at Leavenworth.)

Before LaVerne Peterson purchased the building pictured here in 1962, it had several other owners. She renamed it Chikamin Hotel, its old name, after she bought it. It was decided that LaVerne's building would be an ideal place to start the Bavarian remodel since it was due for repairs and she liked the designs she was presented. The initial design was rejected by city council, mostly because the roof was too pitched. Snow piles up quite heavily in the winter and council members worried that sliding snow would be hazardous to the pedestrians. A different design was drawn up and approved. The photographs here show the progression of the construction. The building was renamed the Edelweiss Hotel, and it carries that name today. (Right, courtesy of the Upper Valley Museum at Leavenworth; below, courtesy of the *Leavenworth Echo*.)

This building was constructed in the early 1890s by a Mr. Weigand. It has had several owners through the years and housed grocery stores, dress and gift shops, and even a brothel upstairs at one time in the early 1900s. Ruth Smith owned Ruth's Dress and Sport Shop from the 1930s to the 1950s. This building, purchased by Ted Price and Bob Rodgers in 1966, was one of the first six buildings to be remodeled in the Bavarian style. The March 1966 photograph above shows the beginning of the remodel in which the front entrance was relocated to the side of the building. The photograph below was taken in September 1966 after the completion of the work. (Above, courtesy of the Upper Valley Museum at Leavenworth; below, courtesy of the *Leavenworth Echo*.)

This building, erected in 1908, was purchased by Enoch Larson in 1944. He operated Larson Drugs in it from 1944 to the 1960s. The *Leavenworth Echo* ran the photograph at right on July 14, 1966. The caption below said, "Enoch Larson joyfully points to the beginning of construction on his store front, another in the increasing list of Bavarian styled architecture." It should be noted that the Bavarian-styled remodeling of the storefronts was at the owner's expense. The building being remodeled below was originally built in the early 1900s. It was a coffee shop and then a bakery, which it has been ever since with various owners. (Right, courtesy of the *Leavenworth Echo*; below, courtesy of the Upper Valley Museum at Leavenworth.)

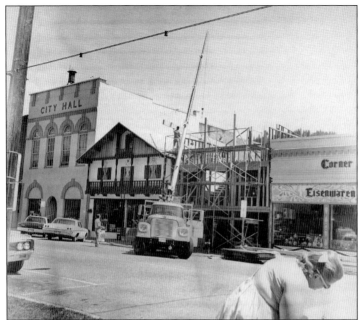

The photograph at left of the continuing Bavarian remodel was taken in July 1968. Earle and Ruth Little were once the owners and ran Little's Mercantile Company. Earle was a well-known international ski jumping judge. Later Rod and Ann Simpson bought the building and ran a department store. They took care of the Bavarian remodel. Today it is a gift shop. (Courtesy of the Upper Valley Museum at Leavenworth.)

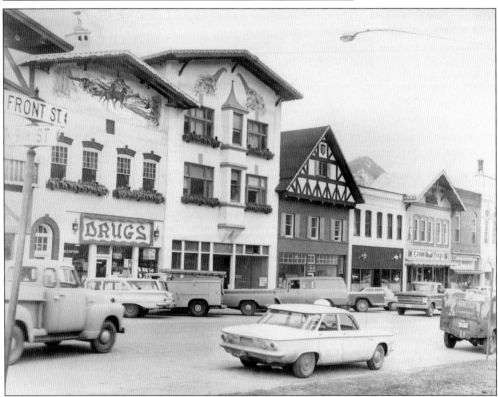

These Bavarian buildings, from left to right, are Cascade Drugs owned by the Plummers, the Herrett building, a craft supply store owned by the Bertholds, the Icicle Tavern owned by a Mr. Massey, and Larson Drugs owned by Enoch Larson. Owners have come and gone, but the buildings remain with their Bavarian designs today. (Courtesy of the Upper Valley Museum at Leavenworth.)

This statue of the ski jumper holding his skis, carved by Art McKellips of Tacoma, is located in an alcove between the barbershop and the liquor store, now known as the Hat Shop and the Wood Shop on Front Street. Chuck and Vera Bergeman purchased the building and opened Chuck's Barber Shop. Chuck remodeled the shop in Bavarian style and hired artist Herb Schraml to paint a mural depicting the ski jumps on the front. In the below photograph, from left to right, are contractor Lloyd DeTillian and architect Herb Schraml. Schraml is the architect responsible for most of the Bavarian designs in Leavenworth. Both photographs were taken in August 1966. (Both courtesy of the *Leavenworth Echo*.)

Artist Herb Schraml was brought to Leavenworth from Seattle by architect Heinz Ulbricht to paint murals on the Edelweiss building and the two Herrett Buildings. In the above August 1966 photograph he is shown finishing up the cornucopia paintings on one of the Herrett buildings. According to the *Leavenworth Echo*, he usually started his work early in the summer months because he was unable to work in the midday heat. The photograph at left was taken in October 1966 when Schraml was creating the 60-foot-long mural on the side of the Seattle-First National Bank Building, now home to clothing shops and the Wood Carver Gallery. Schraml's work is still enjoyed by visitors and locals today. (Both courtesy of the *Leavenworth Echo*.)

The Tyroleans, a German band of four men, were one of the bands that played in the city park on Front Street during the third annual Autumn Leaf Festival. The *Leavenworth Echo* reported on September 22, 1966 that "Men and women, young and old could not resist singing, clapping of hands and keeping time with the music whenever the Tyroleans played." (Courtesy of the *Leavenworth Echo*.)

The city hall building, now known as Village Pharmacy, was built in the late 1890s. During the rail and sawmill days, this building was a hub of activity, as it was a grand opera house that featured burlesque shows and performers such as hypnotists and comedians. The original structure of the building lent itself to the Bavarian design, so major remodeling was not necessary. (Courtesy of the *Leavenworth Echo*.)

Visitors to Leavenworth are greeted by this welcome sign that is situated in the city park along U.S. Highway 2. In the September 1966 photograph above, autumn foliage decorates the base of the sign. The September 1966 photograph below shows visitors who came by train. Special festival trains brought visitors to the Autumn Leaf Festival, which ran for nine days. This particular train arrived on a festival Saturday and was 17 cars long; it brought around 800 people to town. The parks were bustling and sidewalks were packed throughout the day. It was estimated that more than 10,000 visitors came to enjoy the festival in 1966, a far cry from the visitors who came during the Depression era when the railroad and lumber mill left town. (Both courtesy of the *Leavenworth Echo*.)

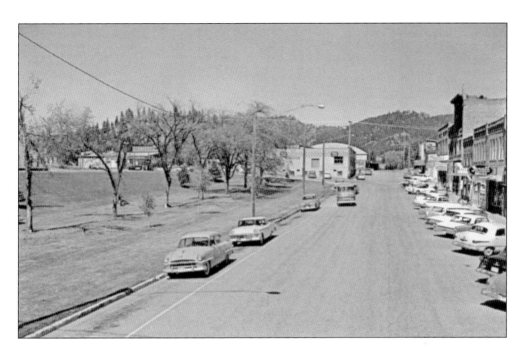

These photographs are nearly the same view: the above in 1960 and below in 1966. Townspeople were ready and motivated to make a difference and bring visitors to Leavenworth, so the Bavarian construction took relatively little time to complete on these Front Street shops. During the Autumn Leaf Festival of 1966, around 10,000 people visited, some arriving by trailer caravan. The Wally Byam Caravan Club is an organization dedicated to Airstream mobile home travel. The 115 trailers in the Autumn Leaf Festival caravan were encamped on the high school football field for several days. Special busses also brought visitors into town. (Above, courtesy of Bill Haines; below, courtesy of the *Leavenworth Echo*.)

This photograph shows the construction on the Seattle First National Bank Building. The local bank manager, Ray Alvarez, was interested in adopting the Bavarian theme and he helped persuade Seattle First to make the modifications to the building. Note the tree decorated with streamers on the roof. This seemed to be a prank at first, but it was discovered that architect Heinz Ulbricht placed it there upon completion of the roof and it follows an age-old tradition known as the Richtfest, which marks the "topping-out" or completion of the framework of a building. The October 6, 1966, the *Leavenworth Echo* reported, "This is done in Germany on any building under construction. Following the placing of the tree, the crew is given a half day off with pay, but they must remain on the job while the owner of the building and the contractor bring them food and drinks. According to Heinz, this custom is hundreds of years old." (Courtesy of the *Leavenworth Echo*.)

The Seattle First National Bank, with nearly complete Bavarian modifications, is shown in these two photographs from October 1966. Before it became Seattle First, it was the Leavenworth State Bank headed by R. B. Field. It became Seattle First in 1956. The mural on the side of the building was painted by artist Herb Schraml. More murals were scheduled to be painted on the front of the building. In 1993, the Huntington Boyd family traded its site on U.S. Highway 2 for this Front Street building to be used as retail space. The vacant lot next to the bank was paved and used as a driveway and parking lot. The Red Baron Gift Haus stands there today. (Both courtesy of the *Leavenworth Echo*.)

This is the view from the top of city hall in September 1967. Icicle Ridge and Tumwater Canyon are visible in the distance. The building at the end of the street is the Tannenbaum building. In the lower right-hand corner of the photograph easels are set up with local artists' work, known as Art in the Park. Art in the Park began in 1966 and is now the longest continually running outdoor art show in the Pacific Northwest. Credit for this event goes to many dedicated townspeople and artists. It evolved over time; tents and tables were added later and the art showings were promoted in the *Leavenworth Echo*. The first showings with only a few paintings were on April 30 and May 1, 1966. Word got out and the following weekend's show drew around 500 visitors. Commission collected from the sales of the artwork went toward upkeep of the park, but now commissions go toward providing scholarship funds for students pursuing a higher education in the arts. (Courtesy of the *Leavenworth Echo*.)

This building was built by Bob Smith and was the Gateway Shell service station in the 1930s. In 1965, owners Annette Hart and Dick and Rena Stroup remodeled it to reflect the Bavarian style and added the onion dome to the top. A fire in the 1990s nearly destroyed the building, but it was remodeled again to become the current Gustav's restaurant. (Courtesy of the *Leavenworth Echo*.)

In the 1940s and 1950s this building was the Variety Store, which was owned by Clarice Ingebretson and Lorene Young, who went on to become mayor of Leavenworth in 1979. Die Kunst Gallerie was located here in the 1960s and other businesses were housed downstairs. Artist Herb Schraml once held art classes at the Gallerie. Today the Andreas Keller restaurant is housed downstairs and Café Mozart is upstairs. (Courtesy of the *Leavenworth Echo*.)

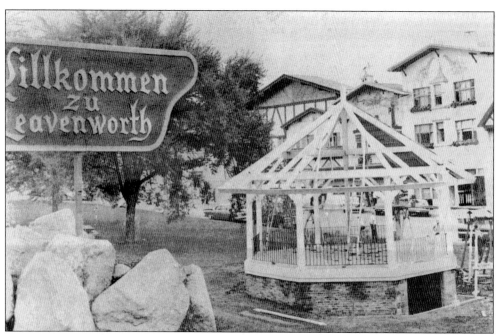

The Front Street park once had a bandstand built in 1910, but it was removed some years later. In the 1960s, when Leavenworth adopted its Bavarian theme, key townspeople felt that one was needed. In 1966, Carolyn Schutte, one of the most generous supporters of Leavenworth, donated $1,000 to get started. She also donated thousands of feet of riverfront property to the town for Waterfront Park, as shown in the photograph below. The bandstand was completed in 1967 with Schutte's and other benefactors' help, along with donations from the Jr. Vesta Women's Club, which was quite instrumental in beautifying the town. (Above, courtesy of the *Leavenworth Echo*; below, author's collection.)

IN HONOR OF

MRS. A. CAROLYN SCHUTTE

THE FUTURE ALONE WILL SHOW FORTH THE PLEASURE ENJOYED BY PEOPLE, AS A RESULT OF MRS. SCHUTTE'S GIFT OF THOUSANDS OF FEET OF RIVER FRONT TO THE TOWN OF LEAVENWORTH. MRS. SCHUTTE ALWAYS SAID THAT ALTHOUGH, IN AN EARTHLY WAY, SHE HAD OWNERSHIP OF THIS LAND, IT WAS REALLY OWNED BY GOD.

THE PEOPLE OF THE CITY OF LEAVENWORTH EXPRESS DEEP-FELT GRATITUDE TO MRS. SCHUTTE; AND DESIRE THAT THIS GENEROUS GIFT WILL ALWAYS BE USED FOR THE BENEFIT OF OTHERS, IN THE SAME SPIRIT IN WHICH IT WAS GIVEN TO THE TOWN.

1973

The editorial pictured here ran in the November 17, 1966, edition of the *Leavenworth Echo*. While many changes occurred during 1966, many people still felt unsure about the transformation of the town since most business owners had to put up the money themselves for construction costs. But local folks did indeed move forward. Posing in the photograph below is John Espelund, owner of Jorgen's Danish Bakery. He is seen here admiring the murals painted by local artist Herb Schraml, who painted most of the murals in Leavenworth. Owners have come and gone, but this location has always housed a bakery. (Both courtesy of the *Leavenworth Echo*.)

EDITORIAL

AN INSPIRING CHANGE OF CIRCUMSTANCES

Passing almost unnoticed is the fact that there have been established in Leavenworth the past year, at least seven new enterprises. Included in the list are two gift shops, one coin shop, a knitting shop, an architectural office, an upholstery firm and a coin-operated laundry. In addition, a service station is now being remodeled into a combination store and station which is expected to be open soon.

Notice the variety of services represented in these new businesses. Also of considerable interest are the reports of additional new shops which will probably develop this coming year.

A comparison of circumstances as they are now, to the way they were a few short years ago is indeed an inspiration.

Ted Price, pictured above, was an avid booster for the Leavenworth community. He and Bob Rodgers started out in Leavenworth when they purchased the Squirrel Tree restaurant. They chose a Bavarian Swiss theme for their establishment and it was such a hit that they decided to add a motel to the property. Ted and Bob became more involved in community planning and Ted ended up becoming president of the chamber of commerce in 1968. He once tried to resign, but the chamber would not accept it. The *Leavenworth Echo* reported on February 8, 1968, that "With all that has taken place in the past two years, the Chamber finds itself deeply involved in many phases of community development. It was felt that at this point it is essential to carry on with these various projects and expand on them wherever possible. This requires the assistance of a President who has worked closely with these projects for several years." (Courtesy of the *Leavenworth Echo*.)

Eight

ALL-AMERICA CITY

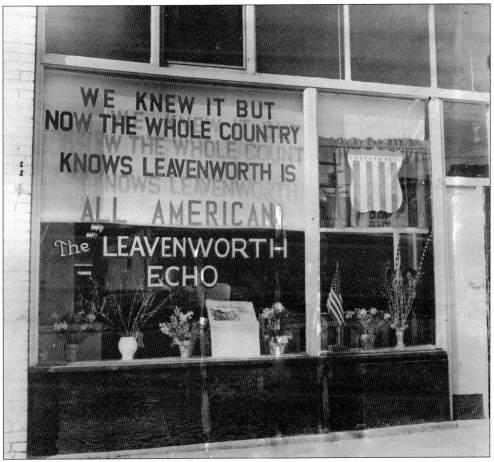

In 1968, Leavenworth was one of 11 cities who received *Look* magazine's All-America City award. This award went to communities whose citizens demonstrated an ability and desire to transform their town for the better. Leavenworth and the 10 other cities were picked from a field of 116. (Courtesy of the Upper Valley Museum at Leavenworth.)

LOOK looks us over

Stanley Gordon, journalist for Look publications and photographer Tom Koeniges were scheduled to be in Leavenworth yesterday and today to obtain pictures in connection with the All America City contest.

They called Pauline Watson from Los Angeles, stating that they would fly to Seattle Wednesday morning. Koeniges will fly to New York with the pictures after leaving here.

January 1968 was an exciting time for Leavenworth's citizens. When Leavenworth was chosen to be among the finalists, delegates were invited to Milwaukee, Wisconsin, to make a final presentation to the All-America City jury. The delegates did so at their own expense. The article at left ran in the *Leavenworth Echo* on January 18, 1968. *Look* writer Stanley Gordon and photographer Tom Koeniges visited as a follow-up to Leavenworth's participation in the All-America City contest. They spent two days observing activities such as skiers on the Leavenworth Ski Hill, art classes at Die Kunst Gallerie, and snowmobiling on the golf course. Pictures were taken in the downtown park of children skiing down the small hill and, of course, the remodeled buildings also drew their attention. The Leavenworth High School ski team turned out for pictures on the high school campus and some residents even arranged an impromptu dinner for Gordon and Koeniges. (Courtesy of the *Leavenworth Echo*.)

Stanley Gordon, left, and Tom Koeniges visited Leavenworth in January 1968 on behalf of *Look* magazine. Here they pose on Front Street in front of the Tannenbaum building. The photograph below, taken by Koeniges, appeared in the January 25, 1968, edition of the *Leavenworth Echo* with the following caption: "'I feel like a beast,' said photographer Tom Koeniges as he tried to get the tiny skiers to carry all of their equipment through the snow in the city park, and still remain upright. The tiny skiers are Miki Brown, Ruth Ann Parsons, Rena Maki, Becky Kruckshank and Raymond Schmitten." (Right, courtesy of the *Leavenworth Echo*; below, courtesy of the Upper Valley Museum at Leavenworth.)

HONORABLE WILBUR F BON
MAYOR OF LEAVENWORTH
617 PINE ST
LEAVENWORTH WASH.

 IT IS A PLEASURE TO CONGRATULATE YOU, YOUR ASSOCIATES
AND THE PEOPLE OF LEAVENWORTH FOR YOUR SELECTION AS ONE OF THE NATIONS
ALL AMERICA CITIES. WE HAVE BECOME AN URBAN SOCIETY AND THE FUTURE
HAPPINESS OF ALL OUR PEOPLE DEPENDS ON WHAT WE DO IN OUR CITIES TODAY.
THE EXAMPLE YOU HAVE SET OF FARSIGHTED CONSTRUCTIVE ACTION IN
MUNICIPAL AFFAIRS DESERVES THE APPLAUSE OF EVERY CITIZEN.

 HUBERT H HUMPHREY

 1150AM MAR 21 1968

 FKOPD
 OLYMPIA WASH
 MARCH 21 1968 1127AM

WILBUR BON
MAYOR
LEAVENWORTH WASH.

DEAR MR BON CONGRATULATIONS TO YOU AND THE CITY OF LEAVENWORTH FOR
BEING NAMED AN ALL AMERICAN CITY. IT IS INDEED A FITTING TRIBUTE
TO THE OUTSTANDING COMMUNITY SPIRIT DEMONSTRATED BY THE TRANSFORMATION
OF THE CITY OF LEAVENWORTH INTO A BAVARIAN VILLAGE SINCERELY

 DANIEL J EVANS GOVR.

The congratulatory telegram from Vice Pres. Hubert Humphrey and Gov. Daniel Evans above arrived on March 12, 1968. The photograph at left shows, from left to right, Vera Lee, wife of Russ Lee who published the *Leavenworth Echo* for 18 years; Pauline Watson, one of the first shopkeepers to remodel her storefront; Bob Rodgers, who along with partner Ted Price and other key townspeople lobbied for the Bavarian reconstruction; and Mayor Wilbur Bon. As noted in the All-America City Award article, which appeared in the April 16, 1968, edition of *Look* magazine, "[the] Ski Tournament, Autumn Leaf Festival, art shows—have hauled in the tourists and once again made Leavenworth worth something to its own people." They are seen at left proudly reading the telegram together. (Both courtesy of the *Leavenworth Echo*.)

Media outlets from around Washington State traveled to Leavenworth to cover the announcement of the All-America City Award. This March 1968 photograph is of Don Dickson and photographer Pay May of KOMO television from Seattle standing next to the television station's vehicle. May had visited the previous summer to film an "Exploration Northwest" program. KING television of Seattle also sent a film crew to Leavenworth. Both stations broke the news to the public. They are standing on Front Street near the Seattle First National Bank building and the building that once housed the liquor store. The ski jumping mural, painted by Herb Schraml, is visible on the storefront, and a portion of the Tannenbaum building, owned by Ted Price and Bob Rodgers, is visible in the background. Leavenworth's transformation occurred over a relatively short period of time and, almost overnight, resulted in the town becoming the popular tourist destination it is today. (Courtesy of the *Leavenworth Echo*.)

The All-America City award celebration drew hundreds of visitors who lined both sides of the street. To the right (above), artwork on easels can be seen as part of Art in the Park, which is specially held on festival days. The photograph is of the All-America City parade. It lasted about 45 minutes and was led by the color guard, escorted by the Peshastin American Legion Post. Several decorated open cars followed, the first being occupied by Mayor Wilbur Bon and his wife, Alverda. They were followed by John Poppy, senior editor of *Look* magazine, and Bob Rodgers and Pauline Watson, who were instrumental in promoting the town. The Leavenworth Jaycees are seen below with the U.S. flag and the All-America City flag. (Both courtesy of the *Leavenworth Echo*.)

The Edelweiss Dancers followed along in the All-America City Parade. Parades and festivals were some of the reasons the city won the award. The first Autumn Leaf Festival was held in 1964 in which there was a small parade. The parade today includes around 80 floats. It was decided that other festivals would be successful and it would be a wonderful way to share in the community spirit and spend family time together. The first Christmas Lighting Festival was held in 1966. Tremendous crowds over the years prompted the chamber of commerce to add a second weekend. The festival runs for three consecutive weekends today and has drawn national attention. *Good Morning America* featured the festival in 2006 and 2007 and the A&E Network dubbed Leavenworth "The Ultimate Holiday Town USA." The first Maifest was in May 1971. Everyone enjoyed live entertainment and a variety of activities. The Edelweiss Dancers performed as well as Tyrolean bands and accordionists. It took pride and dedication from the residents of Leavenworth to create such a festive town. (Courtesy of the *Leavenworth Echo*.)

This display was created in the former Ford garage building where several attractive window displays have appeared during the past few years. The person responsible for these displays is Leavenworth resident Kay Koenig, who was chosen to be Royal Lady of the Autumn Leaves in 1977, so naturally an All-America City display was the choice in April 1968. The building, which housed this display, is located on U.S. Highway 2 and was once the home of Cascade Motors, the Ford garage and dealership from the 1940s to the 1960s. It is now the home of the John's Real Estate Corporation, Sandy's Waffle and Dinner Haus, and the Leavenworth Pizza Company. Other tenants have been the Leavenworth Chamber of Commerce, engineers, printers, and a barber. It was remodeled in the Bavarian design and a clock tower was added. It is definitely a distinctive landmark today. (Courtesy of the *Leavenworth Echo*.)

Nine

COMMUNITY PRIDE

Upon planning Leavenworth's Autumn Leaf Festival, it was decided that a "Royal Lady" would preside over the festivities. Each year since the first festival in 1964, a Royal Lady of the Autumn Leaves was chosen. The October 1968 photograph above features the current and past Royal Ladies. Posing, from left to right, are Martha Jensen, 1964; Margaret Motteler, 1965; Daphne Clark, 1968; Marion Speer, 1966; and Alverda Bon, 1967. (Courtesy of the *Leavenworth Echo*.)

This was the Darling building in the early 1900s, which housed the Dwight Darling Drug Store until around 1930. Pauline and Owen Watson bought the building in the early 1960s, so it became the home of Watson Electric. The Watsons were among the first to remodel their shop when Leavenworth decided to incorporate a Bavarian theme. The Christmas decorations in the above photograph became a standard sight in Leavenworth through the years. Shopkeepers proudly decorated their newly designed storefronts and displayed lights that added to the festive air and attitude of community spirit. Everyone got into the swing of things and in December 1966 the first Christmas Lighting Festival was held. It took a few years for it to become a huge success but in 1981 a second weekend was added to the festival. (Courtesy of the *Leavenworth Echo*.)

Leavenworth began entering floats in the annual Apple Blossom Festival Parade in 1927. The photograph above is of Leavenworth's first entry, titled "Flowers of the Foothills," which took first prize. The float entered in the 1968 Apple Blossom parade titled "Music in the Park" definitely had a Bavarian flair. Leavenworth fifth-graders made apple blossoms for the tree in the center of the float, and several residents participated in the parade. Accompanying the float were men in lederhosen and red vests. This float won the President's Trophy, an award presented to the float that best portrays a Pacific Northwest industry or scenic attraction. Activities like these were proudly presented by Leavenworth residents and they increased tourist traffic to the town. (Courtesy of the Upper Valley Museum.)

The Leavenworth Chamber of Commerce was always forward-thinking and interested in making the city as beautiful as it could be. A major beautification project occurred in the spring of 1968. The Cascade Garden Club and other volunteers worked hard on the Front Street park, adding new plants and trees here and there. Flowers were also planted around the base of the Willkomen zu Leavenworth sign along U.S. Highway 2. Prior to the beautification, many merchants were using plastic or silk flowers. In the spring these days, the streets of Leavenworth are a riot of color with flowers and plants overflowing from their baskets. (Both courtesy of the Upper Valley Museum at Leavenworth.)

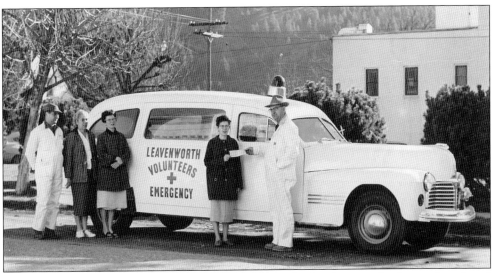

Leavenworth would not be where it is today without the local spirit of volunteerism. Local organizations spent an amazing amount of time and resources to better the town. The Jr. and Sr. Vesta Women's Clubs were involved in obtaining resources such as the ambulance in the above November 1959 photograph where Leavenworth volunteer fireman Dan Farrimond accepted a check from Mrs. Ray Barker for $623.44. The Jr. Vestas also won for the Leavenworth community the $10,000 prize from the Sears Roebuck Foundation and the General Federation of Women's Clubs, which they put toward projects such as building the town bandstand. The Cascade Garden Club was instrumental in beautifying the town. They are seen in the 1968 photograph below adding colorful plants to the base of the welcome sign. (Above, courtesy of the Upper Valley Museum at Leavenworth; below, courtesy of the *Leavenworth Echo*.)

Visitors to Leavenworth on festival days or weekends would commonly see Archie Marlin in the park making hot peanut brittle. He often donated the funds to worthy causes, such as sending delegates from Leavenworth to Milwaukee when the city was in the running for the All-America City Award. When his Candy Kitchen and Art Gallery located in the Tumwater Canyon burned to the ground, townspeople helped him and his wife rebuild. He was director of Art in the Park in 1967 and was able to increase exhibiting time from a weekend to five days. He was dedicated to making this venture a success. In addition to his director duties, he built easels and pushcarts for artists. Today Art in the Park is the longest-running outdoor exhibit in the Pacific Northwest. Commissions are used to provide scholarships and fund other worthwhile community activities. (Courtesy of the Upper Valley Museum at Leavenworth.)

Ted Price was one of many individuals who helped to make Leavenworth what it is today. He is seen in this December 1968 photograph receiving an All-America City plaque for his efforts as president of the chamber of commerce and for his work in the community. Senator-elect Bob McDougall, left, presents the plaque. Price and his partner, Bob Rodgers, felt a deep commitment to the Leavenworth community. This pride in community is still a hallmark of Leavenworth today. As the chamber of commerce states on its Web site, "Leavenworth will continue to grow and expand as the most outstanding Bavarian village this side of the Atlantic. The people of Leavenworth are the town's biggest asset and it is those people that will continue to make Leavenworth 'the little town that could.'" (Courtesy of the *Leavenworth Echo*.)

ABOUT THE ORGANIZATION

The Upper Valley Museum at Leavenworth has been in existence since 2002 when a dedicated group of people got together with the interest of starting a historical museum about Leavenworth and the surrounding area. The museum was once a branch of the Wenatchee Valley Museum and Cultural Center, until 2007 when it began to operate on its own.

The Upper Valley Museum celebrates and promotes the diverse heritage of the Upper Wenatchee Valley by preserving the past and opening a window to the future. The museum provides programming, exhibits, and many community events. It offer memberships, which help support the preservation of artifacts and the oral history of the upper valley, ongoing exhibits, Women in History performances, annual educational programming, exhibits from Central Washington museums, exhibits provided by local artists, and a children's educational series.

The home of the Upper Valley Museum at Leavenworth is the former summer home of Lafayette Lamb of the Lamb-Davis Lumber Company. It then became the home of the town banker, R. B. Field, where he also had a barn and raised purebred champion Arabian horses. Owners since then have included Carolyn Schutte, Ted Price and Bob Rodgers, and Elisabeth Saunders. The property currently covers approximately 5 acres along the beautiful Wenatchee River. (Courtesy of the Upper Valley Museum at Leavenworth.)

BIBLIOGRAPHY

A Pictorial History: Leavenworth. Battle Ground, Washington: Pediment Publishing, 2005.

DaleRail.com. "Searching for the Great Northern in Tumwater Canyon." Fr. Dale Peterka. dalerail.com/Tumwater%20Canyon.htm (accessed August 10, 2010).

D. C. Linsley's 1870 Skagit River survey for Northern Pacific. "Old Records Bring to Light Details of Railway Reconnaissance in the Northwest in 1870." Skagit River Journal. www.stumpranchonline. com/skagitjournal/Railroad/SLSE-NP/Linsley02-CivilEngineering193205.html (accessed July 1, 2010)

Discovering Washington's Historic Mines Vol. 2. Arlington, Washington: Oso Publishing Company, 2002.

Entrix, Inc. *Preliminary Tumwater Canyon Reach Analysis of Wenatchee River and US2, Milepost 94 to 98*. March 2009.

Ferg, Roberta Hatmaker. *Celebrate Leavenworth's Centennial 1906–2006: A Walk Through Time*. Leavenworth, Washington: self-published, 2006.

Price, Ted. *Miracle Town*. Vancouver, Washington: Price & Rodgers, 1997.

Rex's Forest Fire Lookout Page. "Dirtyface Ridge Fire Lookout Cabin." Rex Kamstra. www. firelookout.com/wa/dirtyface.html (accessed August 2, 2010).

Roberts, Honi. *Leavenworth Then, Leavenworth Now*. Leavenworth, Washington: Laughing Deer Books & Photos, 1996.

Roe, Joann. *Stevens Pass: The Story of Railroading and Recreation in the North Cascades*. Caldwell, Idaho: Caxton Press, 2002.

Ruby, Robert H. and John Arthur Brown. *A Guide to the Indian Tribes of the Pacific Northwest*. Norman, Oklahoma: University of Oklahoma Press, 1986.

Scheuerman, Richard D., *The Wenatchi Indians: Guardians of the Valley*. Fairfield, Washington: Ye Galleon Press, 1982.

Visit Leavenworth Washington—The Official Site of the Leavenworth Chamber of Commerce. "Media and Press." Leavenworth Chamber of Commerce. www.leavenworth.org/modules/ pages/?pageid=63&path=63 (accessed June 30, 2010).